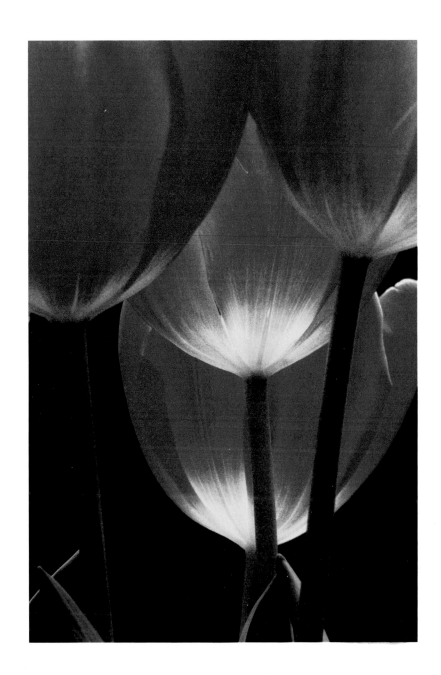

**Polaroid 35mm
Instant Slide System**
A User's Manual

Lester Lefkowitz

Polaroid
A Polaroid book

All photographs by Lester Lefkowitz except where noted.

This book was planned, prepared, and produced by the Publications Department of Polaroid Corporation.

Director of Public Relations and Communications
Samuel Yanes

Publications and Exhibitions Director
Constance Sullivan

Project Editor
Andrea Davis

Technical Editor
Pamela Duffy

Production Manager
James Fesler

Technical Advisors
Samuel Liggero, Stanley Mervis, Carl Schultz, Vivian Walworth. Also: Carl Chiulli, Betsy Fitzgerald, Henry Gale, Jack Goshtigian, Kenneth McCarthy.

Technical Assistants to Lester Lefkowitz
Colleen Daly, Andrea Gutmann, Vincent Tambone.

Designed by Logowitz + Moore Associates, Boston, MA. Typesetting by Monotype Composition Company, Boston, MA. Printed by Acme Printing Company, Medford, MA.

Library of Congress Cataloging in Publication Data
Lefkowitz, Lester.
 Polaroid 35mm instant slide system.
 Includes index.
 1. Instant photography.
 2. Slides (Photography)
I. Title.
TR269.L44 1984 770 84-19856

ISBN 0-240-51707-5

Focal Press
Boston • London
Sydney • Wellington
Durban • Toronto

Contents

**Free and rapid
technical assistance**
If you ever need additional help
in the use of your Polaroid 35mm
system, call us Monday-Friday,
9 a.m. to 6 p.m. (Eastern Time).

From anywhere in the continental
U.S.A., call toll free at (800)
354-3535. Or, write to Technical
Assistance, Polaroid Corporation,
784 Memorial Drive,
Cambridge, MA 02139.

▷ Acmite crystals at 40X magnification were photographed on Polachrome film. Note the excellent color saturation of this 35mm film, which can be processed in minutes without a darkroom. Polachrome is ideal when deadlines must be met, when technical uncertainties in photography must be resolved, and when you must be assured that a good image is on the film.

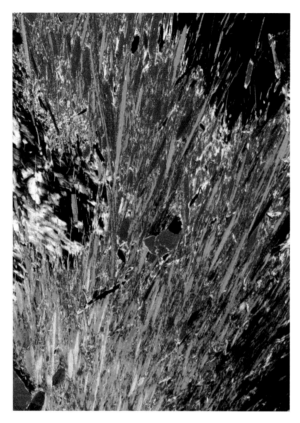

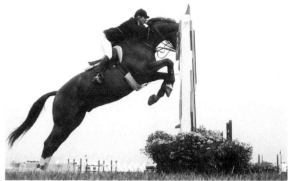

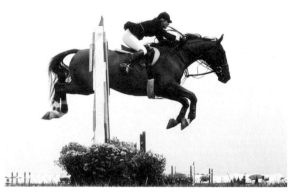

▷ Polagraph high-contrast film produces excellent 35mm black-and-white slides of type, line art, and other high-contrast originals, such as this technical line drawing. The rapidity and convenience of producing finished slides afforded by all Polaroid 35mm instant films is advantageous for slide presentations in business, education, science, and all fields of communication.

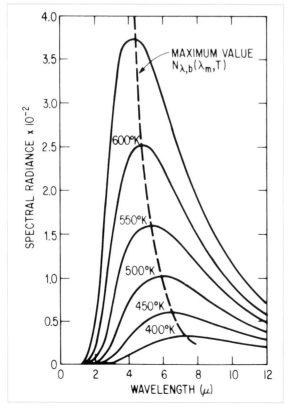

▲ Jumping horse was photographed at $1/1000$ sec. on Polapan film. These frames are two of a sequence exposed with a motor-driven camera at 5 frames per second. The ability to perform 35mm instant tests in the field is a tremendous help in the setup, lighting, and calibration of difficult photographic situations.

1 The 35mm instant slide system

The system

The Polaroid 35mm instant slide system is a combination of remarkable new films and processing components that provides finished, mounted slides entirely without the use of a darkroom, wet chemicals, or elaborate temperature control.

Polaroid's three 35mm films come in standard cartridges and can be used in virtually all cameras, instruments, and accessories that use conventional 35mm film. *Polachrome* is an ISO 40/17° color slide film. *Polapan*, rated at ISO 125/22°, produces continuous tone, black-and-white, positive slides. *Polagraph*, rated at ISO 400/27°, produces high-contrast, positive black-and-white slides and is suitable for copying type, line art, and computer output.

Although designed for projection, Polaroid slides can be converted into prints, or duplicated, by using any of the common instant or wet darkroom techniques used for conventional transparency films.

The entire developing process, which requires less than five minutes, occurs in the compact, portable AutoProcessor. Each film cartridge is supplied with a processing pack that is used once and discarded. A manual slide mounter and plastic slide mounts complete the system.

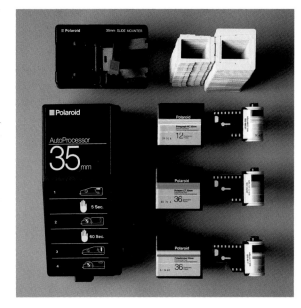

The instant films

Polachrome CS

Polachrome is a 35mm instant color slide film rated at ISO 40/17°. It is available in 12- and 36-exposure cartridges. The film is balanced for use in average daylight or with electronic flash; filters permit its use under tungsten, fluorescent, and other forms of illumination. Polachrome features include very good color fidelity, excellent color saturation, medium grain, and high resolving power. Contrast is similar to conventional films, but the brightness range is shorter and the base density higher. Polachrome film is suitable for all types of general and technical photography.

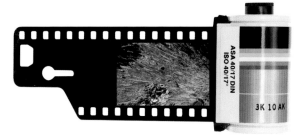

Polapan CT

This continuous tone, black-and-white film (ISO 125/22°) produces positive 35mm slides and comes in 36-exposure cartridges. It features panchromatic sensitivity, fine grain, high resolving power, and excellent separation in highlight and middle tones. Contrast and base density are similar to conventional color slide films, but the brightness range is shorter. Aside from general photography, other uses for Polapan include copying X-rays, photographic prints, and artwork from books, as well as images displayed on computer terminals and scientific and medical devices.

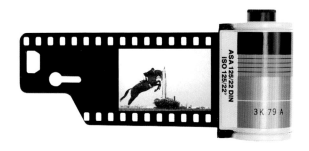

Polagraph HC

Polagraph film produces positive, very high contrast, black-and-white 35mm slides. Its medium granularity and resolving power, combined with a very clear base, produce excellent slides of graphs, charts, titles, typewritten copy, line art, technical plans, and computer output. Its panchromatic sensitivity is ideal for copying originals with black or colored lines, as well as for strengthening or dropping out colors through the use of filters. At ISO 400/27°, it can even be used in a handheld camera to convert continuous tone scenes to graphic abstractions.

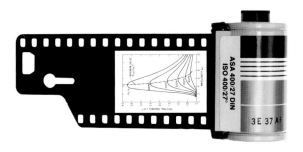

Film characteristics

Characteristic	Polachrome film	Polagraph film	Polapan film
Color balance	Daylight	—	—
Spectral sensitivity	—	Panchromatic	Panchromatic
ISO speed: Daylight	40/17°	400/27°	125/22°
Tungsten	32/16°*	320/26°	80/20°
Exposure latitude	+1, −½ stop	±⅓ stop	+1, −½ stop
Contrast (gamma)	2.0	4.0	2.0
Film emulsion resolution (line pairs per mm)	90	90	90
Granularity	Medium	Fine	Fine
Processing time**	60 sec.	2 min.	60 sec.
Processing temperature latitude, °F (°C)†	72 ± 12 (22 ± 7)	72 ± 12 (22 ± 7)	72 ± 7 (22 ± 4)
Projected brightness base density	0.7	0.05	0.2
Exposures per cartridge	12 or 36	12	36

*Filtration required for proper color rendition. See table on page 29.

**Below 70°F (21°C), process all films for two minutes.

†Best results are obtained at 70°F (21°C).

The AutoProcessor and processing pack

The heart of the Polaroid 35mm instant film system is the Auto-Processor. Less than 9 in. (23 cm) long and under 24 oz. (0.7 kg) in weight, this totally self-contained, eminently portable "darkroom" processes all three Polaroid 35mm instant films. It requires no electricity, batteries, or water, and film washing and drying are eliminated. The AutoProcessor is rugged enough to travel safely in a camera bag or suitcase.

The jelly-like chemical reagent required to process Polaroid 35mm films is safely sealed in a pod inside a small plastic *processing pack*. Each roll of film comes with a processing pack, used for that roll only and then discarded. Processing packs are labeled and color-coded to match corresponding films.

In addition to a pod of reagent, each processing pack contains a roll of black polyester *strip sheet*. During processing, the reagent is applied to the strip sheet. The reagent-coated strip sheet is then laminated to the exposed film. After 60 seconds (2 minutes for Polagraph film), the strip sheet is rewound into the processing pack, and the film is completely developed and dry.

The processing pack is shown (*below right*) to reveal the reagent pod and roll of strip sheet inside. Note, however, that this picture is shown only to inform. *Do not attempt to open the processing pack or touch anything inside an opened pack.*

Caution: The Polaroid instant film process uses a caustic jelly which is safely packed inside a sealed container inside the processing pack. **If accidentally you should get some of this jelly on your skin, wipe it off immediately.** To avoid an alkali burn, wash the area with plenty of water as soon as possible. **It is particularly important to keep the jelly away from eyes and mouth.** Keep the discarded materials out of the reach of children and animals, and out of contact with clothing and furniture, as discarded materials still contain some jelly.

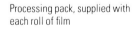

◄ Processing pack, supplied with each roll of film

Internal view of processing pack ▼

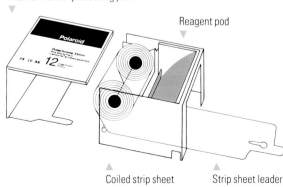

Reagent pod

▲ Coiled strip sheet ▲ Strip sheet leader

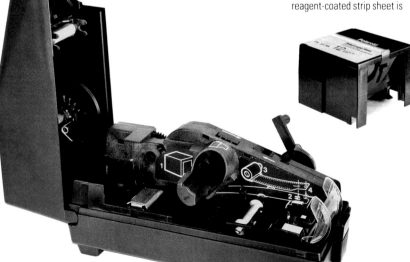

▲ AutoProcessor shown open

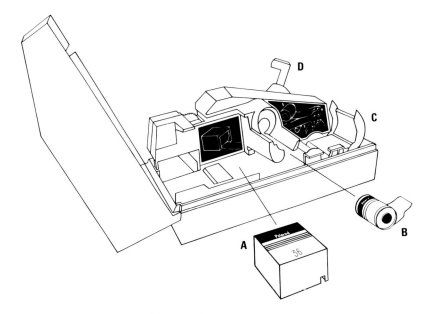

Loading

This diagram of the Auto-Processor with its light-proof cover opened shows the location of the film cartridge and processing pack. Step-by-step directions for loading and processing appear on the next two pages. Note that conventional film *cannot* be developed in the Auto-Processor, nor can Polaroid instant 35mm films be developed with conventional wet chemistry.

A Processing pack

B Exposed 35mm film cartridge

C Take-up spool

D Film advance and rewind crank

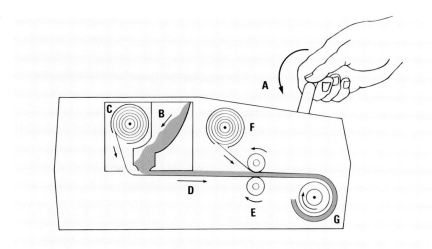

Processing

After loading the processing pack and film and attaching both leaders to the take-up spool, the AutoProcessor's cover is closed. Pressing the control lever opens the processing pack and simultaneously ruptures the pod of the chemical reagent. Gravity feeds the reagent to a tapered applicator, which spreads it evenly onto the surface of the strip sheet. As the crank is turned, the coated strip sheet and film pass through a pair of stainless steel rollers, which laminates them. A take-up spool temporarily stores the film/strip sheet lamination.

A Crank to advance exposed film and strip sheet

B Processing fluid

C Strip sheet

D Strip sheet coated with processing fluid

E Laminating rollers

F Exposed film

G Take-up spool

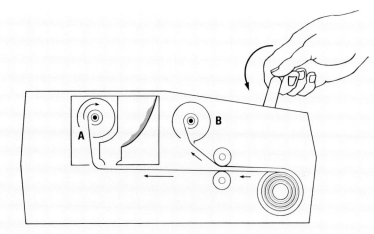

Rewinding

Once the entire length of film is wound onto the take-up spool, it takes 60 seconds (2 minutes for Polagraph) for development. The crank is then turned again to separate the strip sheet from the film (the negative layer is removed with the strip sheet). The strip sheet rewinds into the processing pack; the developed film rewinds into its cartridge. The film is now ready for viewing, cutting, and mounting, and the spent processing pack is discarded.

A Strip sheet with negative layers

B Developed slides

Film processing

A roll of Polaroid instant 35mm film can be processed completely in less than five minutes. Polachrome and Polagraph film and the processing pack must be between 60°-85°F (15°-29°C). Polapan should be processed at 65°-80°F (18°-27°C). *For all three films, best results are obtained at 70°F (21°C).* (See page 63 for additional information on processing temperature.) If the processing pack was refrigerated

or the film exposed in a low-temperature environment, allow it to warm up at least one hour at room temperature before processing.

The AutoProcessor should be operated on a firm, level surface, away from sources of dirt and dust. Outdoors, shield the unit from windblown particles such as sand.

Open the AutoProcessor by pulling out the latch on its front, while simultaneously raising the cover. Also, unfold the handle on the crank on the right side of the processor. Inside the front of the processor is a large plastic spool whose clear lid should be facing *up*; if necessary, grasp and rotate it by hand. Open the clear lid. Blow out all dirt and dust inside the processor, and check the rollers for chemical residue (see pages 59-61).

The film leader must be outside the film cartridge in order to load it into the AutoProcessor. If the leader has been rewound into the cartridge, the Polaroid film extractor can be used to retrieve it.

▶ **1**
To retrieve film leader that has been rewound into its cartridge, hold extractor and cartridge as shown. Gently insert extractor between felt lips of cartridge.

◀ **2**
Slide extractor in up to dotted line. Turn protruding cartridge shaft in direction shown. (Do not let go of shaft while turning.) Turn until you feel slight increased tension, or tug, on cartridge shaft. Then withdraw extractor with film leader attached.

▶ **3**
Before loading processing pack, make certain it matches film type and number of exposures on film cartridge. Lot number stamped at lower left of processing pack label must match lot number on film cartridge.

Unhook end of strip sheet from processing pack, and pull it out 4 in. (10 cm).

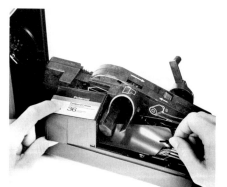

◀ **4**
Place processing pack in its AutoProcessor compartment. Pack should seat easily with definite "click." Feed strip sheet under film cradle as shown. White diagram printed inside AutoProcessor shows loading sequence.

▶ **5**
Strip sheet has keyhole punched into its leader. Attach this to pear-shaped pin on large plastic spool. Press leader all the way down onto pin. Note in photo how strip sheet lies *over* metal roller.

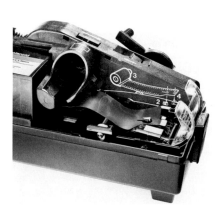

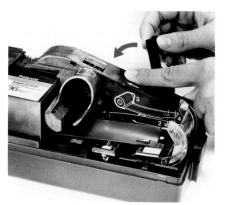

◀ **6**
Slack must be removed from strip sheet. Push release switch in direction shown by arrow. Hold switch in position and turn crank in direction shown until tension is felt and leader lies flat.

7

Pull out about 1½ in. (4 cm) of film from cartridge. Place cartridge in film cradle of Auto-Processor, with cartridge lips facing downward. Make certain cartridge has been pushed as far as possible into cradle.

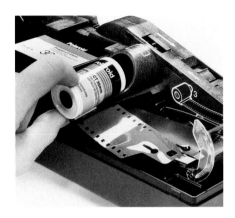

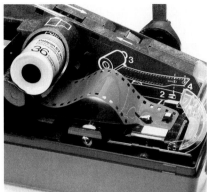

8

Front end of film leader has one keyhole-shaped and one semi-rectangular hole. Attach leader to semi-rectangular pin and then to pear-shaped pin on large plastic spool. Press film to bottom of pins, especially semi-rectangular one. Here, photo shows film with too much slack.

9

If film leader has too much slack, remove film cartridge from AutoProcessor and turn protruding shaft on cartridge in direction shown. Do not let go while turning shaft or its spring tension will counteract rewinding efforts.

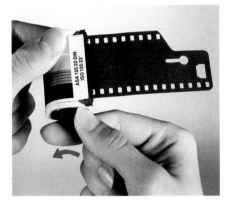

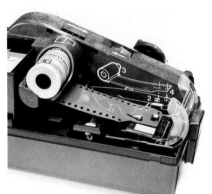

10

When film cartridge and processing pack have been properly loaded with no buckling of strip sheet or film, and you have checked that both film and strip sheet leaders are *securely* attached to their pins, close AutoProcessor cover and gently press down until front latch clicks.

11

To process film, grasp control lever firmly and press down at steady, medium speed. If strong resistance is felt, *do not* force lever. Instead, raise lever all the way up, and push it down again. If resistance persists, open cover and check for proper seating of processing pack.

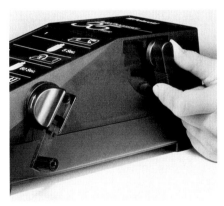

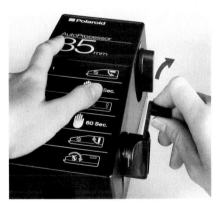

12

After pushing down control lever, *wait 5 seconds*. Then turn crank *quickly* (1-2 revolutions per second) and *smoothly*, without hesitating or stopping, in direction indicated by arrow (turning in opposite direction will damage processor). *Immediately* stop turning when sound of clicking gears stops and additional tension is felt.

13

After cranking, *wait 60 seconds (2 minutes for Polagraph film or for all films when temperature is below 70°F/21°C)*. Then, raise control lever to position shown in photo. During this time, film has been laminated to reagent-covered strip sheet and development is taking place.

Failure to wait recommended time will adversely affect picture quality. Waiting longer is permissible (see page 63).

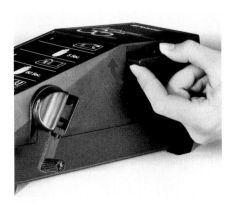

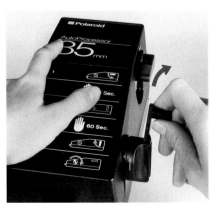

14

Brace AutoProcessor firmly with your left hand; with your right hand, turn crank briskly (about 3 revolutions per second) and steadily in *same* direction used for developing. This separates film from strip sheet. When sound of gears stops, *turn an additional 3-4 revolutions*. Open processor. Immediately remove and discard processing pack, away from children and pets. Do not place it on furniture, books, etc. Film is now ready to inspect and mount (see page 60).

Slide mounting

The developed film is dry and ready for mounting. Before mounting, the film may be pulled from the cartridge for inspection. To avoid scratches, be particularly careful to withdraw the film at the correct angle, and do not place a magnifier directly on the film. (For detailed information, read pages 60-61.)

Polaroid instant 35mm films are identical in size to conventional 35mm films and can be mounted in any standard fashion. Cardboard, plastic, or glass mounts are all satisfactory, and manual or automatic cutting/mounting systems can be used.

Shown below is the Polaroid slide mounter. This unit is designed specifically to work with the hinged plastic Polaroid 35mm slide mounts. The Polaroid mounting system works equally well with conventional film.

Mounting should be performed on a *clean*, smooth surface. Working on a light box or light table facilitates selecting frames to be mounted and the subsequent sorting and inspecting of mounted slides. (See pages 53-55 for suggestions on the best lighting conditions for viewing Polaroid slides.)

Because the emulsion side of Polaroid instant 35mm film has a silvery image surface, it is sometimes difficult to see the frame lines, particularly if the scene has a dark background. A bright overhead light or an adjustable arm lamp makes it much easier to see the lines.

▶ 1
To release film cutting bar on slide mounter, slide blue handle on end of knife to right; bar will pop up.

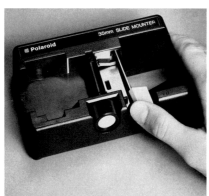

◀ 2
Polaroid mounts will fit any slide tray, including those that hold 140 slides. Rectangular opening meets minimum ANSI specifications. Mounts can be used with any 35mm film.

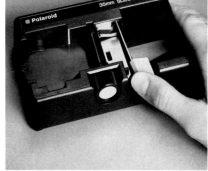

▶ 3
Holding film cartridge as shown, feed end of leader under sprocket wheel. Use right hand to turn film-advance knob and engage sprocket teeth in film perforations. Continue turning knob; at the same time, seat film cartridge in its compartment.

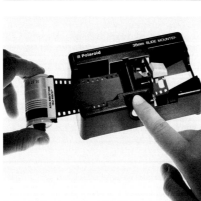

◀ 4
Turn knob to advance film until leading edge of first picture is almost aligned with metal edge below knife. Leave a little bit of space just to the right of picture before making cut. If first picture on roll has dark background, it may be difficult to locate its leading edge. See next step for simple solution to this problem.

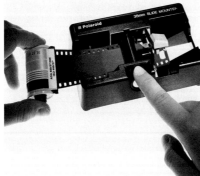

▶ 5
To help locate boundary between film leader and edge of first picture, lift film cartridge out of its compartment and place it next to slide mounter. Align frame line between *first and second* pictures with white guideline on slide mounter. This accurately positions leading edge of *first* picture directly below knife.

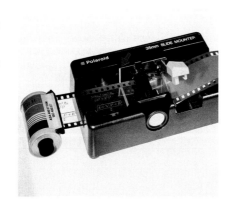

◀ 6
Cut off leader by pushing blue handle down. To ensure a clean cut, exert *slight* pressure toward left on cutting blade. If you have removed film cartridge, put it back into slide mounter after making cut.

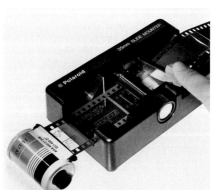

▷ 7

Insert open slide mount into well on right side of slide mounter. Push mount all the way down until it stops. Slots and grooves on slide mount must face up.

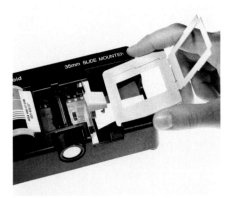

◁ 8

Turn knob counterclockwise to feed film under guide slots located on both sides of mount. Turn until film *just* hits stop at end of guide slots (see next step) and turn no further. Push blue handle down, with slight pressure toward the left, to cut film.

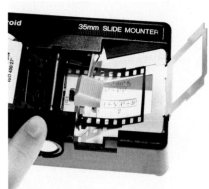

▷ 9

This close-up view shows film guide slots (A) and end stop points (B). Occasionally, film will curl and will not glide under guide slots. First try tilting mount up slightly. If that does not help, you can press down the *edge* of the film with your finger, but *do not touch image area*.

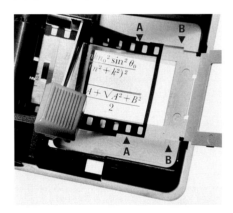

◁ 10

Before cutting, make sure film has traveled all the way to end stops. Film curl (induced by low humidity) sometimes causes film to stop when it touches short side of rectangular slide opening. *Careful* use of a pencil point will lift film edge over that spot.

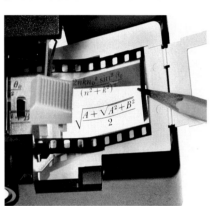

▷ 11

Remove mount from slide mounter. Fold over hinged top section and firmly squeeze all five locking tabs in order shown. Keep fingers away from film. If all tabs are not closed, slide may jam in projector. Mounts are marked LAMP SIDE to aid orientation in projector or enlarger. Use permanent fineline marker to label plastic mounts.

◁ 12

Some cameras generate uneven spacing between frames. Extra wide frame lines (shown by arrow) must be trimmed before inserting film into mount. Knife in slide mounter can easily trim small slivers of film. If film chip is accidentally cut too long and mounted, excess will protrude from area near tab 1 in preceding photo. Carefully remove film from mount, trim with scissors, and reinsert. This prevents film from buckling and causing an out-of-focus projected image.

▷ 13

Polaroid 35mm instant films can be mounted in any standard 35mm slide mount. Fully automated mounters, manual methods that use guillotine cutters, or even scissors can be used. However, the emulsion surface (silvery side) must not be touched: *these films scratch more easily than conventional materials*. As with any film, slides that must withstand a good deal of handling are best mounted in glass.

▷
Polachrome film has the resolving power to record very fine details as well as the color fidelity to capture subtle tones and pastel hues.

▷
Polachrome film also retains the saturation found in strong, bold colors. Unrepeatable events, such as this oscilloscope trace, can be photographed, and the film immediately developed in any office, lab, studio, or plant. This ensures pictures that are accurate, technically correct, and successfully recorded. Any necessary changes are apparent immediately.

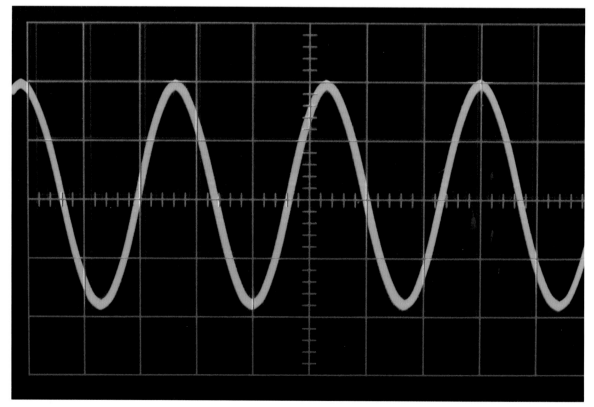

General description

Polachrome color slide film is rated at ISO 40/17° and is available in 12- and 36-exposure cartridges. Color is balanced both for daylight and electronic flash. With appropriate filters, the film can be used under tungsten, fluorescent, and most other forms of illumination.

Although intended primarily for projection, Polachrome slides can be converted to color prints, instant or conventional, through direct reversal or internegative printing.

Polachrome film's resolution of 90 line pairs per millimeter permits faithful recording of fine details. Color fidelity and color saturation are very good.

Grain is comparable to that found in very high-speed conventional films. Under most projection conditions, grain is not apparent. When slides are converted into prints – 5 x 7 in. (13 x 18 cm) and larger – grain is usually noticeable, especially in areas of a single tone with little detail. Additionally, shadow

areas have more graininess than lighter tones, and graininess also increases with underexposure.

Contrast is equivalent to that of conventional films. However, exposure latitude and brightness range are about 1⅓ stops less on the dark end of the tonal scale.

Unlike conventional color films, which have *three* separate emulsions used to record the red, green, and blue portions of the visible spectrum, Polachrome has only *one* light-sensitive layer that is coated with a microscopic

pattern of red, green, and blue filter stripes (see next page) These stripes are usually invisible when projected but are more noticeable in large prints.

This system of color generation requires handling, viewing, projection, and printing techniques that differ in small, but important ways from conventional films. To ensure optimum success with Polachrome film, these differences must be understood.

The Polachrome color system

Conventional chromogenic color materials – slides, negatives, and prints – are composed of three or more light-sensitive layers that lead to formulate yellow, magenta, and cyan dye images during development. As white light passes through the developed film, each dye layer passes its own color, but *subtracts* its complementary color. When the appropriate amounts are subtracted, the remaining light that

gets through comprises the color image in all its various hues.

Polachrome film creates a full color spectrum by using an *additive* process. The base of the film, which faces the lens during exposure, is coated with a screen of minute, transparent red, green, and blue stripes. Behind the screen is a *single*, panchromatic, light-sensitive silver halide layer.

During exposure, the color stripes filter light falling on the silver halide emulsion. They also

filter light passing through the developed image during projection, adding appropriate amounts of red, green, and blue light to create the visual sensation of virtually any color (see pages 16 and 18). The amount of light passing through each stripe is determined by the amount of developed silver halide behind it.

The four photographs below demonstrate the additive color phenomena. Red, green, and blue

spotlights simulate the color screen in Polachrome film. It is interesting to note that Polachrome and color television are the only extensively used imaging systems currently utilizing the additive color process. However, before the invention of practical subtractive color film in the 1930s, the additive process, exemplified by Autochrome plates, was used for most color photography.

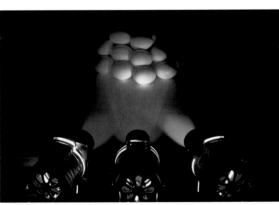

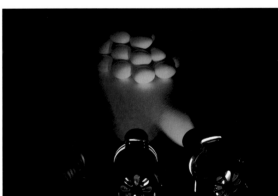

◀ Equal amounts of red, green, and blue light combine to create white. Colored shadows occur when one or more light beams cannot reach obstructed or recessed areas.

▶ Blue and green (two of the additive primary colors) combine to produce cyan (one of the primary colors in the subtractive system).

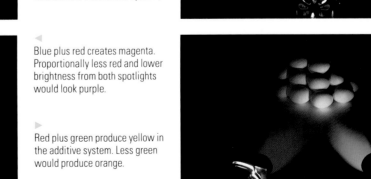

◀ Blue plus red creates magenta. Proportionally less red and lower brightness from both spotlights would look purple.

▶ Red plus green produce yellow in the additive system. Less green would produce orange.

The color screen

The width of each color filter stripe accurately inscribed on the base of Polachrome film is 0.0003 in. (0.0084 mm). Side by side, in the order of red, green, and blue, there are 1,000 red-green-blue triplets per inch (394 per centimeter) running parallel to the length of the film.

Human visual acuity cannot differentiate such closely spaced lines, therefore, we see the blending of various combinations of stripes as unbroken areas of color. If high-quality magnifying optics are used, the array of stripes will become *just* visible to most observers somewhere between 6X-10X magnification. (Note that when projecting a slide, the typical combination of screen width and viewing distance presents no more than a 2X-4X effective magnification to the eye. This is considerably less magnification than necessary to detect the color screen stripes in Polachrome film.)

A consequence of the additive color screen—which is present in the film both before and after development—is that the base density of Polachrome is about 0.7. When compared to the 0.2 base density of conventional film, the viewing brightness of Polachrome is 1⅔ stops less. This has no effect whatsoever on prints made from slides, because the neutral density is cancelled out in the printing process.

When projected, the increased base density of Polachrome film generally is unnoticed, except when intermixed with conventional slides and under such adverse conditions as high ambient light. Suggestions for increasing projection brightness are provided on pages 56-57.

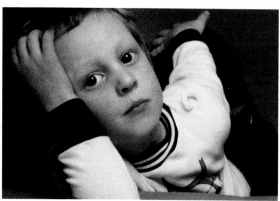

Full-frame print from a Polachrome slide is shown here at 2X magnification. Stripes that comprise additive color screen are invisible below 6X.

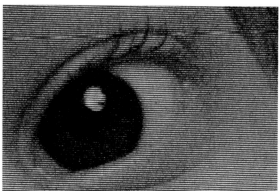

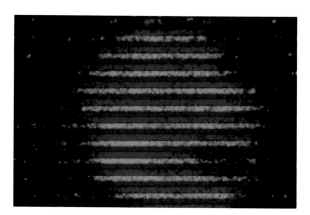

A 30X magnification (*right*) of child's eye clearly shows stripes of the Polachrome additive color screen. At about 250X (*far right*), "white" highlight in pupil of eye is shown actually to consist of red, blue, and green stripes of equal width. Black stringy material, which is really developed silver, is behind stripes. This silver blocks light, making pupil appear dark everywhere but in highlight area.

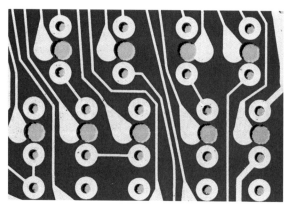

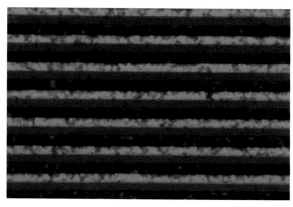

To show that red, green, and blue stripes can create other colors, yellow dot on Polachrome slide of circuit board (*right*) is enlarged approximately 400X (*far right*). Developed silver blocks only blue filter stripes, allowing light to pass through all red and green filter stripes. And, as shown on page 15, red plus green creates yellow.

Color quality

Like all color films, Polachrome has its own characteristic palette. Some colors are reproduced with excellent fidelity, for example, blues, greens, and many pastels. Reds generally appear a bit bolder and more saturated than the original hue. Yellow is the weakest and least accurate color.

The original slides (*right*) of the Macbeth ColorChecker actually have more highly saturated colors when projected than when reproduced here.

The accuracy of color in a slide very much depends on the color quality of the illumination used for photography. Polachrome film is balanced for daylight (5500K), daylight defined as "blue sky plus noon sun." When used under other conditions, Polachrome may require corrective filtration (see pages 26-31).

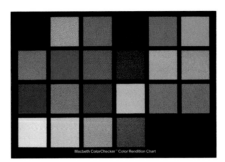

Polachrome

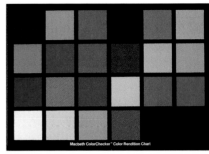
Kodachrome 64

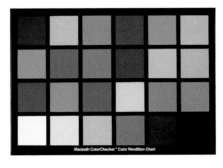
Ektachrome 200

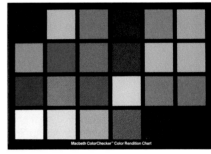
Ektachrome 400 push-processed 1 stop to E.I. 800/41°

Bold colors of circuit board and wires (*right*) reproduced well on Polachrome film. Primary illumination came from 3200K tungsten lights; a Wratten #80A color conversion filter was used. A spotlight with yellow gel highlighted metallic tracks on board. Polachrome also renders accurate pastel tones, as shown in skin, hair, and eyes (*far right*). Whites are very neutral and have excellent tonal separation. This portrait was taken with studio electronic flash.

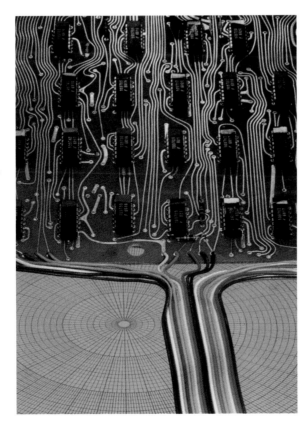

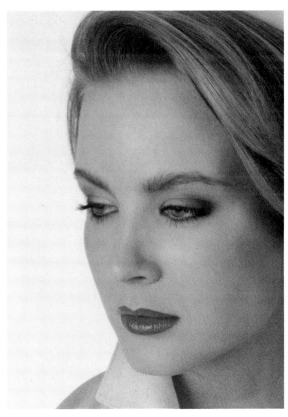

Film structure and image formation

This diagram shows a cross section of Polachrome film that has been exposed but not processed.

Note that light from the lens goes through the base *first*, as it travels to the light-sensitive silver halide layer. This configuration is unlike conventional films, where the light-sensitive layer is closest to the lens.

Each of the color filter stripes in the additive color screen transmits light of its own color, and blocks light of complementary colors. The transmitted light then passes to and exposes the silver halide directly behind the filter stripe.

In this example, yellow light (which is made up of red and green light) passes through the red and green filters, but is blocked by its complementary color, the blue filter. Green light passes through the green filter stripe and is blocked by the red and blue stripes. White light, which is made up of red, green, and blue light, passes through all three filters.

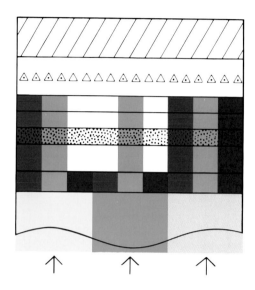

Black antihalation layer
Exposed silver halide grains △
Unexposed silver halide grains △
Release layer
Positive image protecting layer
Positive image receiving layer

Color screen protecting layer

Additive color screen

Clear polyester support (not to scale)

Light from camera lens

In the AutoProcessor, a thin coating of processing fluid is applied to the strip sheet as it is pulled from the processing pack. The strip sheet, in turn, transfers the processing fluid to the upper surface of the exposed film.

The processing fluid permeates the upper layers of the film where it reacts with the silver halide layer. The chemicals have no effect on the color filter stripes, which are protected by a separate layer. The filters remain an integral part of the film, both before and after processing.

Polapan and Polagraph film have the same image formation mechanism as Polachrome, except they lack the color filter stripes. The chemical formulations of the silver halide layer and processing fluid are also somewhat different.

Processing fluid

Black antihalation layer
Exposed silver halide grains △
Unexposed silver halide grains △
Release layer
Positive image protecting layer
Positive image receiving layer

Color screen protecting layer

Additive color screen

Clear polyester support

The processing fluid rapidly reduces the *exposed* silver halide grains to silver; the *unexposed* silver halide grains are dissolved, and the dissolved silver migrates to the positive image receiving layer.

Black antihalation layer
Developed silver grains ▲
Dissolved silver grains ⸌⸍
Release layer
Positive image protecting layer
Positive image receiving layer

Color screen protecting layer

Additive color screen

Clear polyester support

The dissolved silver halide is converted to opaque, metallic silver in the positive image receiving layer. Image formation is now complete.

The entire developing process takes 60 seconds (2 minutes for Polagraph film). The processing fluid is formulated and applied in a manner that supplies just the correct degree of chemical activity for the image to develop to completion. The film cannot overdevelop, regardless of the processing time.

Black antihalation layer

Developed silver grains ▲
Release layer
Positive image protecting layer
Developed positive silver
in positive receiving layer

Color screen protector

Additive color screen

Clear polyester support

After 60 seconds (2 minutes for Polagraph film), the film is rewound in the AutoProcessor into its original cartridge. During rewinding, the upper layers of the film are peeled away and wound into the processing pack with the strip sheet.

The silver halide grains which were exposed, and subsequently developed, are peeled away, leaving complementary clear areas above the color filter stripes. Conversely, the silver from those silver halide grains not exposed to light is now deposited as opaque, metallic silver above the color filter stripes.

If a color filter transmits no light during exposure, the metallic silver deposited behind it will be very dense and opaque. If a filter transmits a moderate amount of light, the density of the silver will be proportionally less. If a great deal of light is transmitted during exposure, the film will be almost perfectly clear behind that filter segment.

Black antihalation layer

Developed silver grains ▲
Release layer
Peeling occurs here

Positive image protecting layer
Developed positive silver

Color screen protecting layer

Additive color screen

Clear polyester support

Light from the projector passes through the slide's clear areas, but is blocked by the opaque silver in other areas. The silvery-appearing surface of the film is, in fact, metallic silver.

Silver has formed behind the appropriate color stripes that are not required for the formation of a particular color. White light from the projector passes through the red and green color filter stripes, but not through the blue filter. The combination of the minute red and green filter stripes is perceived as yellow, as shown in the examples on pages 15 and 16.

Light passing through the green filter stripe is perceived as green, and light passing through the red, green, and blue stripes appears white (see, for example, the white highlight in the eye on page 16).

Light from projector bulb

Positive image protecting layer
Developed positive silver grains

Color screen protecting layer

Additive color screen

Additional technical information

Spectral response

Unlike conventional color films, Polachrome shows no color shift due to reciprocity failure. The shapes of the spectral response curves (*right*) do not change, whether exposure time is $1/30,000$ second or 20 minutes.

The reason is that each of the silver halide layers in conventional film has different reciprocity characteristics. Therefore, the overall color balance changes when the relative sensitivity of individual layers changes. Polachrome film has only one light-sensitive layer. Reciprocity failure *does* require an increase in exposure with Polachrome when shutter speeds are longer than $1/8$ second. Chapter 7 provides more information.

Off the film metering

Another special aspect of all Polaroid instant 35mm films is the location of the light-sensitive layer. When loaded in a camera, the shiny polyester film base is closest to the lens. Behind that is the additive color screen (Polachrome only), then various thin layers required for image formation, followed by the light-sensitive silver halide.

This "base-first" physical arrangement has ramifications for off the film metering systems (see Chapter 9 for a detailed discussion) and for image sharpness.

Very low humidity

Image sharpness is generally not affected by the location of the light-sensitive layer slightly behind the camera's focal plane. Depth of focus adequately compensates. However, the overall thickness of Polachrome film is 0.088 mm, somewhat less than the 0.14 mm average of conventional films. In addition, under very low humidity conditions (less than 30% relative humidity), the film may curl slightly in cameras that have generously deep film channels. These two factors can combine to cause loss of resolution at apertures larger than f/3.5. Using apertures of f/4 and smaller (f/5.6, f/8, etc.) will minimize the error in focus due to curl.

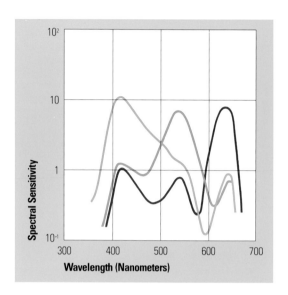

Spectral response of Polachrome (combination of color screen transmission and emulsion sensitivity). Sensitivity is defined as the reciprocal of exposure (ergs/cm^2) required to produce an equivalent neutral density of 0.75.

Brightness range and contrast

Shown below is a step tablet photographed on Polachrome film and on three conventional films. A step tablet is a white-to-black array of gray patches used to simulate the brightness range of a scene. Each step is $1/3$ of a stop.

When compared to conventional, wet-processed slide films, the step tablet photographs show that Polachrome film produces equivalent highlight and middle tone rendition. On the dark, "shadow" end of the scale, Polachrome exhibits about $1\frac{1}{3}$ stops less ability to separate detail in very dark tones. In fact, Polachrome film's rendering of shadow detail is similar to that of push-processed conventional film, but its highlight and middle tone contrast is superior.

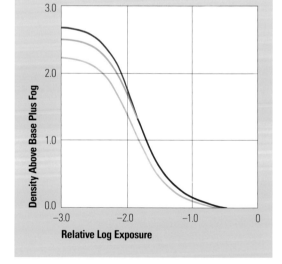

Characteristic curve of Polachrome film, shown minus base density.

Polachrome

Ektachrome 200

Kodachrome 64

Ektachrome 400 push-processed 1 stop to E.I. 800/41°

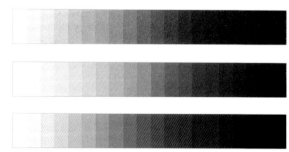

Contrasty lighting conditions

Scenes having an extreme brightness range (harsh sun, contrasty studio lighting, backlighting) are difficult to record on transparency materials; some amount of highlight or shadow detail is inevitably lost. Since Polachrome records about 1⅓ stops less shadow detail than conventional emulsions, contrasty scenes must be treated carefully. Polachrome film's ability, however, to render very dark gray tones as black can frequently be put to positive use for graphic, dramatic, or contrast-enhancing effects.

Outdoors, contrasty lighting is often appropriate for landscapes and architecture; however, conventional portraits and closeups usually benefit from softer illumination. To circumvent contrasty lighting, place the subject entirely in the sun or entirely in the shade. Direct sun can also be blocked with a card, cloth, or photo umbrella. Alternatively, more light can be added to deep shadows with a reflector board or fill-in electronic flash.

Artificial light should be similarly controlled to produce the desired photographic contrast. The human eye can see into shadows far better than any film. In general, studio lights should be adjusted to create shadows that are *lighter* to the eye than desired in the final image. Broad lights are better for this purpose than spotlights, and bounce flash is softer than direct flash.

When the scene has a long brightness range and/or the lighting is harsh and uncontrollable, bracket exposures by half stops, then full stops, on either side of "nominal." This procedure will capture the maximum tonal scale possible and offer a choice of exposures when editing.

Strongly backlit scenes can produce saturated colors and dramatic ambiance, but their extreme brightness range taxes shadow-rendering ability of slide films. Here, more exposure would improve image of child but wash out kite. Moving child and kite into shade, or both into sun, would have been a good solution. Alternatively, fill-in flash could be used to lighten shadowed foreground without destroying backlighting effect.

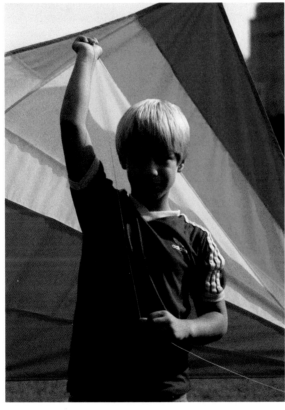

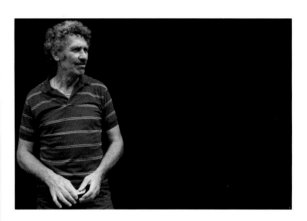

Subject was photographed in total shade, illuminated by sunless patch of sky above tall surrounding buildings. Although picture was properly exposed for subject, textural detail of the building in background was rendered uniformly black because of short brightness range of Polachrome on dark end of tonal scale.

For maximum visual information in technical photographs, very soft lighting usually provides best results. Small, 3 in. (7.6 cm)-diameter spotlight placed 12 in. (30 cm) from circuit board created harsh rendition (*right*). Shadowless version (*far right*) resulted from much larger diameter, 12-in. diffused floodlight placed at same distance. White card opposite light reflected illumination into shadows.

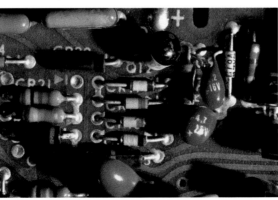

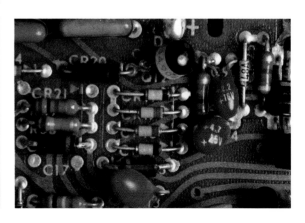

Graininess and granularity

Graininess is the subjective appearance of small, local density variations (due to clumps of silver grains) in a large area of uniform density. Granularity is the objective, scientific measurement of those local variations.

Granularity data are useful when comparing films but correlate with graininess only for fairly specific image-viewing conditions. The primary determinants for graininess are degree of enlargement, viewing distance,

density of the segment under scrutiny, and amount of pictorial detail.

The granularity of Polachrome film is similar to that of high-speed conventional transparency films. As a projected slide, typical combinations of screen width and viewing distance create a magnification for the observer of only 2X-4X. At this magnification, the appearance of graininess is minimized and tonality appears smooth.

When slides are enlarged as prints, however, graininess may be more apparent. Small prints measuring 3¼ x 4¼ in. (8.3 x 10.8 cm) or 4 x 5 in. (9 x 12 cm) exhibit little, if any, graininess. On the other hand, the 8X-12X magnification of an 8 x 10 in. (18 x 24 cm) or 11 x 14 in. (30 x 40 cm) print causes more apparent graininess. All other conditions being equal, graininess is more noticeable in pictures with large

areas of uniform tonality than in pictures filled with small details.

Polachrome film exhibits substantially higher graininess in dark tones (high density areas) than in light tones (low density areas). Graininess is, therefore, more apparent in shadow areas. Similarly, underexposure – which increases overall density – significantly increases graininess (see opposite page). Care should be taken *not* to underexpose Polachrome film.

▷
Slides enlarged 5X and greater into prints have more noticeable grain than do projected images, the latter typically observed at 2X-4X. Grain in prints is most apparent in smooth areas of medium tonality. Section from an 11 x 14 in. print (*far right*) of a Polachrome slide (*right*) shows little grain in light skin tones. But graininess is significantly higher in shadow areas (under the hat brim), a characteristic trait of Polachrome.

▷
Although Polachrome does have noticeably more grain than do conventional films of similar speed, its ability to resolve small details is very good, and scenes busy with detail suppress sensation of graininess. Enlarging the Polachrome image (*right*) of a finely structured feather to 7X (*far right*) equals a full-frame image on 8 x 10 in. paper. In projection terms, 7X is equivalent to viewing a 6-ft.-wide image at a distance of 6 ft. (1.8 m) from the screen. At 7X magnification, grain in this image is virtually indiscernible. Even at 13X (*bottom*), graininess and sharpness are good. However, optimal results depend heavily on correct exposure.

Underexposure materially increases grain; overexposure washes out highlights, eliminating details that contribute to apparent sharpness.

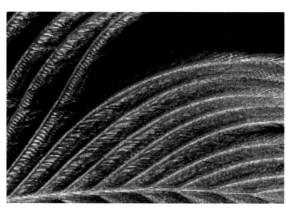

Exposure latitude

Exposure latitude indicates the amount of overexposure and underexposure a film can tolerate and still give acceptable results. Of course "acceptable" is a subjective term, and more important, exposure latitude varies from scene to scene. Flatly lit scenes (e.g., overcast sky, broad/flat studio lights) and scenes having a short tonal scale (not too great a range from light to dark) have a greater exposure latitude than scenes that are exposed by contrasty illumination and/or contain both very light *and* very dark tones.

All positive reversal transparency films (slide films) – instant and conventional – have far less exposure latitude than do negative films. Additionally, Polachrome film can record about 1⅓ stops less on the dark end of the tonal scale than conventional slide films. Therefore, for an average scene with a 7-stop brightness range, the exposure latitude of Polachrome film is about +1 stop overexposure and −½ stop underexposure.

Note again that underexposing Polachrome film increases its graininess, and for projection, exacerbates its fairly high base density. This, coupled with the narrow exposure latitude, strongly suggests bracketing by half stops, then full stops, on either side of "nominal" for contrasty scenes or critical use.

Nominal exposure

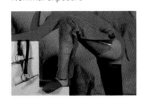

+ ½ stop

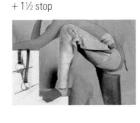

+ 1 stop

+ 1½ stop

This flatly lit studio scene has minimal shadows. Brightness range from yellow foreground support to dark leather chaps on far leg is about 5½ stops. Six photos at left show results of 1½-stop bracketing, by half stops, on both sides of "nominal" exposure. Although subjective, exposure latitude for this scene is about ±1 stop, or +1, −1½ stops for dramatic effect.

− ½ stop

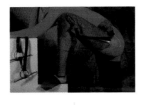

− 1 stop

− 1½ stop

Underexposed slides can be improved somewhat by copying or printing them lighter. These three, from the underexposure series above, were printed to give approximately equal density in the yellows. Note loss of detail in dark areas.

12X enlargement

Although you can project or print through dense, underexposed slides, grain increases in Polachrome film with underexposure.

These sections of the nominal and 1½-stop underexposures were enlarged 12X to show that increased graininess.

12X enlargement

Exposure

Those exposure concerns related to conventional slide films apply also to Polachrome film. Slide films require more accurate exposure than do negative films. Negative films have more exposure latitude, and prints from negatives can be lightened or darkened, both overall and locally, during the enlarging process. These manipulations do not apply as readily to slides.

Overexposure washes out highlight detail in all transparency materials. With Polachrome film, underexposure should also be avoided because it increases apparent graininess and projection density and tends to block up shadows.

Bracketing exposures by half stops, then full stops is recommended when extreme contrast is encountered, or when the subject's brightness differs significantly from the medium tone to which exposure meters are calibrated.

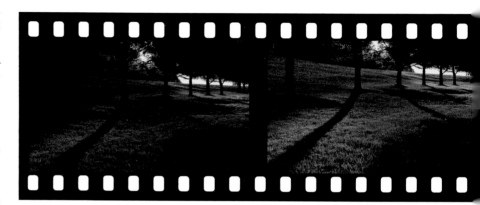

▲
— 1 stop

▲
— ½ stop

Contrasty backlighting and long brightness range of this landscape made bracketing exposures strongly advisable. Nominal exposure (center) was determined by tilting camera down toward foreground to prevent sun from biasing meter reading.

▶
Large areas of sky frequently cause underexposure because most camera meters are overwhelmed by background that is much brighter than subject. Without compensation, sky was recorded as gray, and detail in bird's body was lost (right). Overriding meter with 1⅓ stops more exposure (far right) greatly improved slide of bird.

▶
Very dark backgrounds can fool meters into overexposing subjects and washing out light tones. Incorrect exposure (right) resulted because meter attempted to integrate various brightness elements in scene as medium tone average. Decreasing exposure by about 1½ stops (far right) corrected 5X photomacrograph of radial cross section of insect eye.

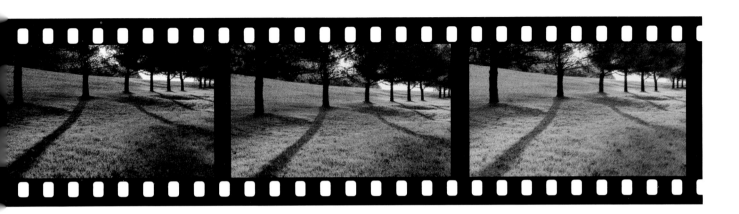

minal exposure + ½ stop + 1 stop

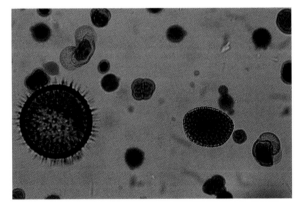
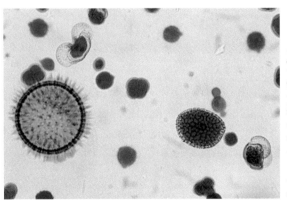

▷ Combination of intensely white background and translucent specimens, such as these dyed pollen grains (about 250X), is found frequently in microscopy. Photomicrographic metering systems cause underexposure in these situations (*right*); increasing exposure time by a factor of six over meter indication corrected photo (*far right*). Polachrome is ideal for quickly determining necessary exposure compensation.

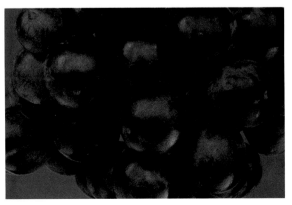

▷ A dark subject should receive more exposure on Polachrome than on conventional materials. The increase is ⅔ to 1½ stops, depending on subject's tone: the darker the subject, the more compensation needed. This counteracts tendency of Polachrome to reproduce dark tones as absolute black. Metering off an 18% gray card produced underexposure in black grapes (*right*); 1-stop compensation offered significant improvement (*far right*).

Specimen courtesy Carolina Biological Supply Co. Inc.

Filters

Filters may be used to warm, cool, color correct, or polarize light when working with Polachrome film. (Filters appropriate for photographing under tungsten, fluorescent, and high-intensity discharge lamps are discussed on pages 28-31. Additional filter data appear on pages 70-73.)

Polachrome film is balanced for 5500K daylight illumination, daylight defined as a mixture of blue skylight and midday sun. The human eye is notably insensitive to changes in the color of ambient light; however, even relatively small deviations from daylight quality affect, to some degree, the color balance of all slide films. In noncritical applications, slight color casts are generally innocuous. In fact, a color imbalance often goes unnoticed unless compared side-by-side with a corrected slide.

Early morning and late afternoon light produce warmer (yellower) slides. Although such an effect is often pleasing, the use of the bluish #82 series of Wratten light balancing filters will correct the color cast.

Similarly, pictures taken on cloudy days, in shade, and across great expanses of mountains or water have a cool (bluish) cast due to ultraviolet (UV) radiation and excessive blue skylight. A Wratten #1A (skylight) filter, which absorbs UV and some excess blue, is strongly recommended for these photographic conditions. In fact, because Polachrome film has a high sensitivity to UV radiation, a #1A filter is recommended for all outdoor photography. For even more blue absorption particularly in the shade, use the yellowish #81 series of Wratten filters.

Placing subject in shade rather than in direct sunlight eliminates harsh contrasts and black shadows but shifts color balance toward blue. This slide, taken on clear, blue-sky day in shade, shows resulting cool color cast (*right*). A more pleasing rendition (*far right*) was achieved by using a Wratten #81C filter.

Before reaching shaded plants on forest floor, light from clear blue sky passed through overhead foliage and became even cooler in color, creating excessively blue slide (*right*). With a Wratten #81D filter, results are far superior (*far right*).

Polarizing filters can strongly affect appearance of slide without adding any color cast. They can turn ordinary blue sky (*right*) into dark, dramatic background (*far right*), though they have no effect on totally cloudy skies. Polarizers can temper, and often eliminate, glare and reflections in glass or water (camera must be at an angle, *not* perpendicular to glass or water). They also cut through haze found above water and in the mountains.

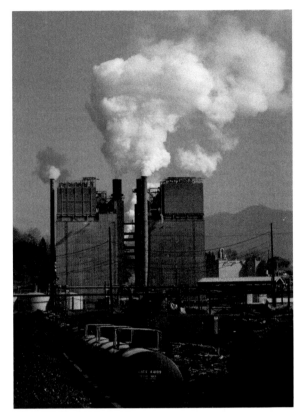

Because electronic flash color quality is similar to daylight, Polachrome can generally be exposed by flash without filtration. However, color quality of flash equipment varies between brands. Some units produce light with cool, bluish cast (*right*), others produce light that is more neutral, and some have slightly warm, reddish light (*far right*). Cyan color compensating (CC) filters neutralize excessive reddish tones; try CC10 or CC20. Yellow CC filters eliminate excessive bluish tones; try CC10 or CC20.

Tungsten light

Polachrome film, which is daylight balanced, can be exposed under tungsten illumination without a filter if color balance is not critical. However, tungsten light has much stronger red and yellow components than daylight has, a characteristic noted far more readily by film than the eye. When necessary, use the appropriate filtration to produce a neutral color balance, without a yellow-orange cast.

Tungsten light sources include all ordinary light bulbs, quartz-iodide or tungsten-halogen photo bulbs, and reflector flood and reflector spot lamps. Each has its own color temperature and therefore requires a specific filter when a very accurate match to the 5500K balance of Polachrome is required (see table on page 29).

Areas illuminated by artificial light tend to have far less brightness than do outdoor scenes. This low brightness level combined with the ISO 40/17° of Polachrome film, lead to tungsten-light exposure times longer than 1/15 second. If you add a filter to balance tungsten illumination with Polachrome, the effective speed will decrease, further lengthening exposure times. To

ensure sharp pictures under these conditions, mount the camera on a tripod or copystand. If this solution is impractical, consider using a flash.

When exposure times become longer than about 1/8 second, you should increase the exposure to compensate for reciprocity failure (see example below and on pages 66-69).

Without filtration, daylight-balanced Polachrome film produced characteristically warm results when exposed near lamp fitted with 60-watt tungsten bulbs (*right*). To obtain more accurate color, two Wratten filters (#80A and #82C) were used (*center*). An unfiltered Kodachrome 64 photograph is shown for comparison (*far right*). For many purposes, the unfiltered Polachrome picture is quite satisfactory; it has a warm glow often associated with indoor light.

Exposure times with tungsten illumination are often fairly long, therefore requiring correction for reciprocity failure, particularly where small apertures are used for maximum depth of field. Uncorrected meter reading off *penicillium expansum* mold indicated f/16 at 8 seconds (*right*). Corrected for reciprocity failure, proper exposure is f/16 at 52 seconds (*far right*).

Specimen courtesy Carolina Biological Supply Co. Inc.

Tungsten light photocopying

An important application of Polachrome is in the production of lecture and presentation slides: images copied from books, drawings, documents, and the like. Such photography is primarily done on vertical copystands that use various types of tungsten bulbs for illumination.

Daylight-balanced Polachrome film requires filtration under such conditions.

Here, the need for color accuracy is often more imperative than in general photography. Correct color rendition is easily achieved by the proper matching of light source and filter using the table below.

A typical exposure with a 500- to 1000-watt copylight system and an f/11 aperture ranges from ½ second to 4 seconds. As with conventional films, these times are well within the range requiring additional exposure for correction of reciprocity failure (see pages 67-69 for appropriate data). Without this easily applied correction, slides will be underexposed by 1 to 2 stops.

Through-the-lens metering off an 18% gray card usually provides the best exposure accuracy. Take your readings after filters are in place, then correct for reciprocity failure. (See pages 100-103 for more information about photographing drawings and illustrations.)

▶
Medical illustration was copied on Polachrome film using 3200K tungsten lamps. Without filtration (*right*), rendition is warm in color. Use of a Wratten #80A filter (*far right*) produces slide color very close to original artwork color. If color accuracy is required, conversion filters are a must.

Illustration by Art and Kim Ellis

Filtration recommendations for Polachrome film and tungsten illumination

Bulb type	Filtration*	Exposure increase** Multiply exposure time by	**or**	Open lens
Household bulbs				
40–60 watt	80A + 82C + CC10C	5		2⅓ stops
75–200 watt	80A + 82B	4		2 stops
Reflector floods				
75-watt	80A + 82C	4		2 stops
150-watt	80A + 82C	4		2 stops
DWC (for Polaroid MP-4)	80A + 82C	4		2 stops
EAL (500-watt, 3200K)	80A	3		1⅔ stops
Photographic bulbs				
3200K	80A	3		1⅔ stops
3400K	80B	2.5		1⅓ stops
BCA (blue photoflood)	80C	2		1 stop
EBW (blue photoflood)	80D	1.5		⅔ stop

Color temperature of tungsten bulbs varies with voltage, bulb age, brand, and diffuser or reflector near bulb. For critical use, photographic tests should be performed.

*Based on tests performed with Kodak Wratten filters. Other brands may give slightly different results. These are starting point recommendations only.

**Applies *only* if external light meter is used and for cameras with meters that do *not* measure light coming through the lens. Cameras with through-the-lens metering automatically compensate for filters. When exposure times are ⅛ sec. or longer, correct for reciprocity failure (see pages 68-69).

Fluorescent light

When color balance is not critical, Polachrome film can be exposed under fluorescent light without a filter. In fact, when exposed under the most common type of fluorescent light, cool white, Polachrome slides generally have a less objectionable color cast than unfiltered conventional film exposed under identical conditions.

Each type of fluorescent tube imparts a particular color cast to slides. For completely neutral pictures, use the filters indicated in the table on the next page. Note that fluorescent light filtration requirements for Polachrome are different—and generally less—than for conventional film. (Fluorescent daylight filters, FLD, which vary considerably, are not recommended for Polachrome film when optimum results are desired.)

Rooms are sometimes fitted with a mixture of fluorescent tubes, such as cool white and warm white. This condition is easy to detect visually, but filtration will have to be determined on a trial-and-error basis, using the data in the table to extrapolate starting points. Polachrome film is an ideal material for such test-and-correct procedures.

Similarly, Polachrome film can be used to determine fluorescent light filtration for conventional film when the fluorescent tubes are of unknown type and inaccessible. For example, if test exposures with Polachrome produce neutral colors when CC20B + CC20C filters are used, the unknown tubes are probably warm white (see table on opposite page). Data from the manufacturer of the conventional film will indicate the corresponding filtration necessary with warm white tubes.

Three fluorescent tubes were photographed, unfiltered, with Polachrome (*right*) and Kodachrome 25 (*far right*) films. Tubes, top to bottom, are cool white, warm white deluxe, and daylight. With Polachrome, the most commonly used tube (cool white) shows minimal color cast.

Ball bearing photographed unfiltered under Aristo fluorescent ring light has a green cast (*right*) characteristic of much fluorescent illumination. CC10M + CC10R filters neutralized color balance (*far right*) indicating that the ring light is similar to cool white in color (see table on opposite page). Because of fluorescent light "flicker," to avoid inconsistent exposures, use exposure times slower than 1/30 second.

Filtration recommendations for Polachrome film and fluorescent illumination

Lamp type	Filtration*	Exposure increase**	
		Multiply exposure time by **or**	Open lens
Cool white	10M + 10R	1.5	⅔ stop
Cool white deluxe	10C	1.3	⅓ stop
Daylight	35R + 10Y	2.5	1⅓ stops
Warm white	20B + 20C	2	1 stop
Warm white deluxe (or Soft White)	20B + 30C	2	1 stop
White	10B	1.5	⅔ stop

Exact color of fluorescent tubes varies somewhat with age, manufacturer, and voltage. Transmission quality of plastic diffuser, if any, also affects apparent color.
*Based on tests performed with Kodak Wratten filters. Other brands may give slightly different results. These are starting point recommendations only.
**Applies *only* if external light meter is used; through-the-lens metering systems automatically compensate for light loss due to filtration. When exposure times are ⅛ sec. or longer, correct for reciprocity failure (see pages 68-69).

High intensity discharge lights

Energy efficient, high intensity discharge (HID) lamps are becoming common in schools, factories, offices, stores, and arenas. They are also used extensively to illuminate roadsides and building exteriors.

HID lamps include mercury vapor, low- and high-pressure sodium vapor, and proprietary metal vapor lamps available under such trademarks as Lucalox, Multi-vapor, Ceramalux, and Metalarc. HID lamps change color significantly as they warm; turn them on at least one hour before photographic work.

As with tungsten and fluorescent illumination, daylight-balanced Polachrome film can be used, unfiltered, with HID lighting. Depending on lamp type, the slides will have anywhere from a slight to a severe color cast. For noncritical applications, the results are generally satisfactory.

When color balance must be accurate, take a test series of slides using different filters. Do not use Polachrome film as test material to determine the filtration for conventional film; the filtration requirements may be different.

This scene includes four different kinds of lighting: fluorescent inside, tungsten on outdoor brickwork, neon window sign, and unknown type of HID lamp illuminating snow. Unfiltered Polachrome slide (*right*) has overall cyan cast due to predominance of HID and fluorescent sources. CC30 red filter minimized color cast in snow and produced satisfactory overall color rendition (*far right*).

Mixture of HID lamps is common; for example, this scene is illuminated by mercury vapor spotlight on church and sodium vapor streetlight in foreground. This picture was photographed without a filter. If filtered for the predominating mercury vapor light, foreground would have been even warmer.

Abstract composition of industrial scene shows beautiful highlight and middle tone separation against dense background of solid black, tonalities characteristic of Polapan film.

3 Polapan film

General description

Polapan is a black-and-white, panchromatic 35mm film, packaged in 36-exposure cartridges, that produces positive, continuous tone slides. The ISO is 125/22° for daylight and 80/20° for 3200K tungsten light. Processed in the Polaroid Auto-Processor, Polapan film is dry and ready to mount five minutes after being unloaded from the camera.

The base density of Polapan slides is only 0.2. This, coupled with a fine grain emulsion having a resolving power of more than 90 line pairs per millimeter, creates a very bright projected image featuring excellent detail and sharpness.

The contrast of Polapan film is similar to that of conventional slide films, but like Polachrome, the exposure latitude and brightness range on the dark end of the tonal scale are about 1 1/3 stops less than those of conventional slide films. Polapan film has particularly pleasing highlight and middle tone separation.

Image formation and development in Polapan film are principally the same as in Polachrome film except that Polapan does not have the color filter stripes. (See pages 18-19 for a detailed explanation of the image development process.)

Polapan film is ideal when continuous tone, black-and-white slides of illustrations, photographs, X-rays, artwork, and images from computer screens and scientific imaging devices are needed quickly. Because slides can be ready for evaluation and editing within minutes, Polapan is excellent film to use in photography classes and for photojournalism. Polapan can also be used as an exposure and lighting test material for conventional films.

Polapan slides can be easily converted into black-and-white prints using instant print materials or conventional darkroom and wet-processing techniques. Such prints can then be used in small newspapers, in-house reports, and catalogs.

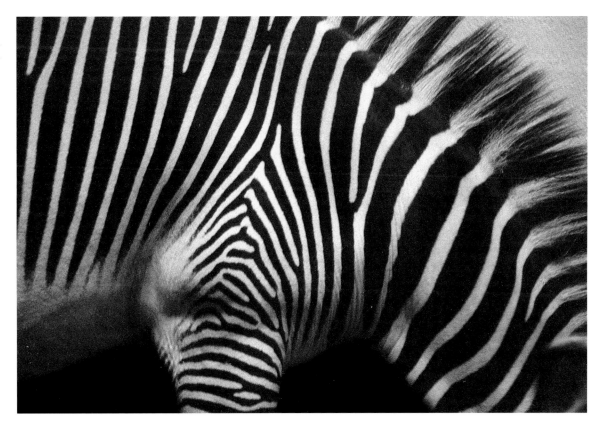

Speed of Polapan film, ISO 125/22°, is suitable for many candid and photojournalistic applications. Zebra was photographed at New York's Bronx Zoo.

When making slides of continuous tone black-and-white photographs and illustrations, use Polapan film rather than Polachrome film. Polapan can be used to make lecture slides from existing Polaroid black-and-white prints – prints commonly exposed in scientific imaging devices such as electron microscopes and medical scanning instruments.

This Polapan slide was made on a copystand from a Polaroid Type 52 print of a scanning electron microscope image (magnification 1600X). It shows ultrastructure just below surface enamel in a fossilized tooth of a Multituberculata, an arboreal, beaver-size mammal extinct for about 35 million years.

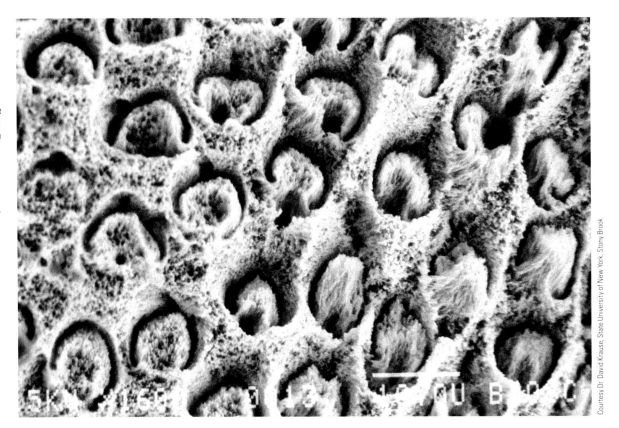

Courtesy Dr. David Krause, State University of New York, Stony Brook

This Polapan slide of a scanning electron micrograph was made on a copystand from a conventional black-and-white print made from a Polaroid Type 55 4 x 5 negative. Image shows lower portion of trigger hair on leaf of Venus's flytrap, a carnivorous plant (magnification 210X). Round, puffy bumps on surface are digestive glands.

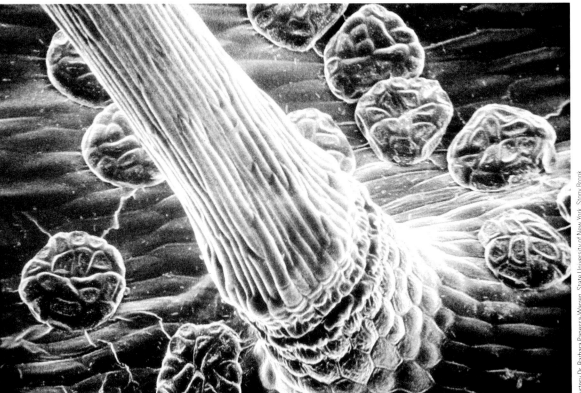

Courtesy Dr. Barbara Panessa-Warren, State University of New York, Stony Brook

Additional technical information

Very low humidity
When exposed under very dry atmospheric conditions (less than 30% relative humidity), Polaroid 35mm film may curl slightly in the camera's film plane. To avoid any loss of resolution, use apertures of f/4 and smaller. (See page 20 for additional discussion.)

Off the film metering
Electronic flash and ambient light metering systems that measure light reflected off the film require special ISO settings when used with Polaroid 35mm film. See Chapter 9 for a complete discussion.

Low base density
Because Polapan film does not contain the fine pattern of stripes that are used to derive color in Polachrome film, Polapan has a significantly lower base density, 0.2 versus 0.7, and shows no line structure when enlarged.

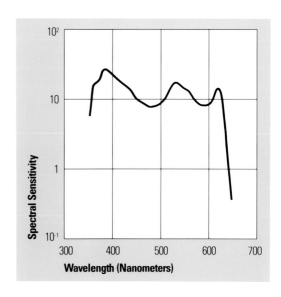

Spectral response of Polapan film. Sensitivity is defined as reciprocal of exposure (ergs/cm^2) required to produce 0.5 visual density.

Brightness range and contrast

Shown below is a step tablet photographed on Polapan and on two conventional slide films. A step tablet is a white-to-black array of gray patches used to simulate the brightness range of a scene. Each step is ⅓ stop lighter or darker than the step next to it.

The step tablet photographs show that Polapan film, in comparison with conventional wet-processed slide films, produces similar highlight and middle tone rendition. On the dark, "shadow" end of the scale, Polapan shows about 1⅓ stops less ability to separate very dark tones.

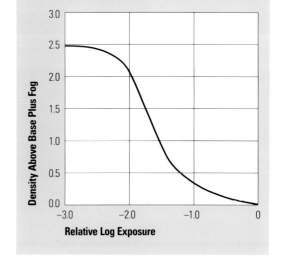

Characteristic curve of Polapan film

Polapan

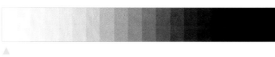

Panatomic-X reversal processed

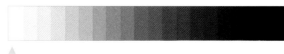

Kodak Ektachrome Professional 50

Contrasty lighting conditions

The exposure latitude and brightness range of black-and-white *negative* films are noticeably greater than those of the black-and-white *slide* films. Therefore, scenes having an extreme brightness range (harsh sun, contrasty artificial lighting, and backlighting) are difficult to record on slide films; some amount of highlight or shadow detail is inevitably lost.

Because Polapan film records about 1⅓ stops less shadow detail than conventional slide films, contrasty scenes must be treated even more carefully. On the other hand, the ability of Polapan, like Polachrome, to render very dark tones as black can be used positively for graphic, dramatic, or contrast-enhancing effects.

Unless such graphic effects are desired, it is best to avoid very contrasty situations when exposing Polapan film. For example, move the subjects from harsh sunlight into shade or use fill-in flash or reflector boards. In the studio, use broad lights rather than small, contrasty spotlights. Also, avoid underexposure, particularly if the subject has dark tones in which you want to hold detail.

Tuba player (*right*) was photographed on Polapan film in outdoor location surrounded by trees and illuminated by overcast sky. Soft light produced pleasant tonality and good detail in highlights and shadows. In comparison, direct sun from clear sky typically produces very contrasty lighting (*far right*); with Polapan film exposed for highlights, shadows became very black and lost detail.

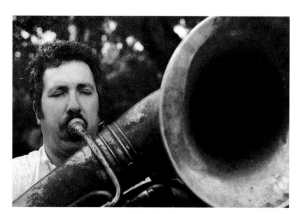

Small, portable flash units aimed directly at a subject produce harsh, contrasty lighting. This is less than ideal lighting for slide films that, for most practical purposes, permit no manipulation of contrast or compression of tones. In slide above, Polapan film's relatively short scale of shadow detail, coupled with contrasty flash illumination and extreme range of light-to-dark tones in subject, caused loss of all detail in black sweater.

▷
Penicillium roqueforti mold was photographed using small spotlight placed at low angle to rake across surface (*right*). Because film records shadow areas darker than they appear to the eye, results are too contrasty. Placing white card opposite spotlight bounced light into shadows (*far right*), providing more visual information on Polapan slide while retaining texture.

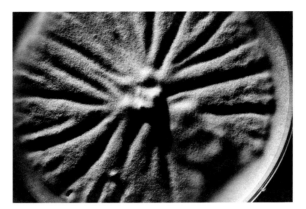
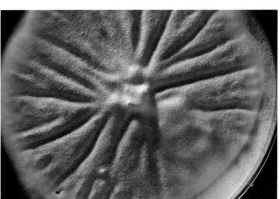

▷
When photographing very dark subjects, remember that Polapan film has about 1⅓ stops less ability to record shadow detail than does conventional transparency film. When taking an incident exposure reading or a reflected reading from a gray card, expose dark subjects 1 to 2 stops more than meter indicates. In this image (*right*), uncorrected meter reading produced slide that is too dark. Opening lens 1½ stops more than meter indicated greatly improved image (*far right*). Reflected light readings taken directly from a dark subject, with either a handheld meter or through camera's metering system, can usually be used without correction.

Specimen courtesy Carolina Biological Supply Co., Inc.

Graininess

When a slide is projected, typical combinations of screen width and viewing distance create an image magnification of only 2X-4X for the observer. This modest magnification, combined with the relatively fine grain of Polapan film, yields a screen image that is virtually free of all discernible grain.

When slides are enlarged into prints, graininess (the subjective appearance of grain) will depend on image-viewing conditions. The primary determinants for graininess are degree of enlargement, viewing distance, density of the segment under scrutiny, and amount of pictorial detail.

Prints from properly exposed Polapan slides exhibit little if any graininess in print sizes up to 8 x 10 in. (18 x 24 cm). For display and exhibit purposes, prints as large as 20 x 24 in. (50 x 60 cm) have very reasonable graininess, particularly when viewed from distances appropriate for large images.

The grain in Polapan film is larger and more noticeable in dark tones. Underexposing this film further increases the grain size in dark tones and also increases graininess in middle tones. Therefore, care should be taken *not* to underexpose Polapan film if prints with minimum graininess are required. (The opposite page shows examples of the relationship of graininess to exposure.)

▷ Grain is less noticeable in busy scenes containing an array of fine detail than in large areas of even tonality. Original slide of lace dress on clothesline (*right*) shows little graininess, even when enlarged to 10X (*far right*). An enlargement of 10X approximates an 11 x 14 in. (30 x 40 cm) print. Compare this 10X enlargement with 10X enlargement below.

▷ When projected, a properly exposed Polapan slide (*right*) is virtually free of noticeable grain when enlarged to 5X (*far right*). Magnification of 5X is about the maximum image perceived by viewer at typical combinations of screen width and viewing distance. At about 10X (*below*), graininess in this properly exposed slide is still low, even in smooth tone areas.

Exposure latitude

Exposure latitude indicates the amount of overexposure and underexposure a film can tolerate and still give "acceptable" results. More important, exposure latitude varies from scene to scene. Flatly lit scenes (e.g., over-cast days) and/or those having a short tonal scale have greater exposure latitude than scenes that are exposed by contrasty illumination and/or contain both very light *and* very dark tones.

Polapan film records about 1⅓ stops less shadow detail on the dark end of the tonal scale than do conventional slide films. Therefore, for an average scene, the exposure latitude of Polapan film is about + 1 stop overexposure and − ½ stop underexposure.

Because of this relatively narrow exposure latitude and the increased graininess when Polapan is underexposed, bracketing exposures by half and then full stops on either side of "nominal" is recommended for contrasty scenes or critical use.

Nominal exposure

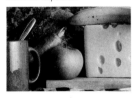

+½ stop

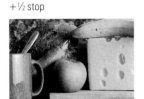

+1 stop

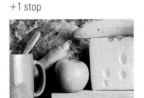

+1½ stop

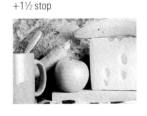

Broad studio lights created fairly flat illumination for this still life; brightness range is about 5 stops. Seven photos at left show results of 1½-stop bracketing, by half stops, on both sides of nominal exposure. Exposure latitude for this scene is about ± 1 stop. Some viewers may prefer the moody darkness of the − 1½-stop exposure.

−½ stop

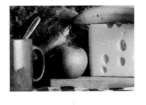

−1 stop

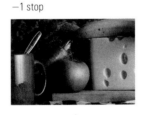

−1½ stop

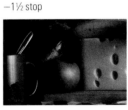

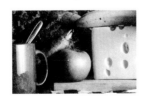

Underexposed slides can be improved somewhat by copying or printing them lighter. These three, from underexposure series above, were printed for approximately equal density in the cheese. Note loss of detail in dark areas.

12X enlargement

You can project or print through dense, underexposed slides, however, grain increases in Polapan film with underexposure.

Here, sections of nominal and − 1½-stop exposures were enlarged 12X to compare graininess.

12X enlargement

Exposure

Exposure concerns related to conventional color slide films apply equally to Polapan film. Slide films require more accurate exposure than do negative films. Negative films have inherently more exposure latitude, and prints from negatives can be lightened or darkened, overall and selectively, during the enlarging process. These alterations cannot be applied as readily to slides.

Overexposure should be avoided because it washes out highlight detail; underexposure should also be avoided because it increases graininess and causes shadows to block up. Bracketing exposures by half and then full stops is recommended when extreme contrasts are encountered, or when the subject is significantly brighter or darker than the medium tone to which exposure meters are calibrated.

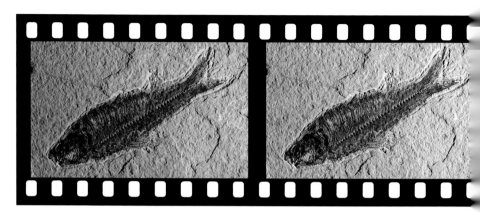

▲ —1 stop

▲ —½ stop

Intentionally contrasty side lighting was used to show texture in 34- to 50-million-year-old Knightia fossil. Nominal exposure was based on average reading; ½-stop bracketing shows lighter exposures are better for fish, darker exposures for background rock.

▷
Combination of exposed light bulbs and white walls "fooled" exposure meter, resulting in underexposure of scene (right). Similar underexposure occurs in scenes having proportionally large, light-toned areas: sky, snow, light-colored clothing or walls, and background in bright-field microscopy. Series of ½-stop bracketed exposures produced improved rendition (far right) +1½ stops from meter reading.

▷
There is not always one best exposure; bracketing helps explore possibilities. To achieve a "normal" rendition of factory, where very bright sky and white steam predominated, exposure was increased 2 stops over meter reading (right). Bracketing on underexposure side produced dramatic back-lit rendition, turning steam into smoke (far right). Exposure was 2 stops less than meter reading.

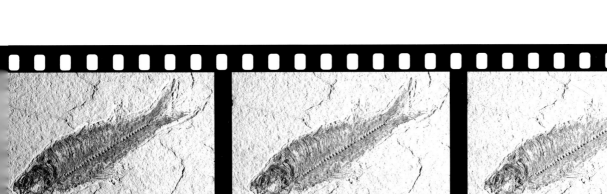

Specimen courtesy Carolina Biological Supply Co., Inc.

▲ minal exposure ▲ + ½ stop ▲ + 1 stop

▶ Polapan film is useful for making lecture slides of black-and-white photographs. If a photograph includes very dark shadow areas, those dark tones may appear as solid black on Polapan slides (*right*). To improve shadow detail in the slide, make a *flashed* slide (*far right*).

To make a flashed slide, first make a normal exposure of the photograph with a camera that can make double exposures. Then cover the photograph with white paper and make a second flash exposure of the paper on the same frame. Flash exposure should be 2⅔ to 3⅔ stops less than used for the main exposure. Make a series of flashing exposures in ⅓-stop increments to establish correct degree of flashing; this can then be used for subsequent work.

Walker Evans

▶ X-rays can be copied on Polapan film to produce slides. X-rays have a long brightness scale, and important information may appear in dark tonal areas. Flashing can be used to prevent subtle dark tones from recording on slides as black (*right*). After main exposure, remove X-ray and photograph light box (*far right*); flash exposure should be about 3⅔ to 4⅔ stops less than main exposure.

Filters

Color in the real world and in color photography plays a major role in the visual differentiation of tones, shapes, and surfaces. When colors of equal brightness, such as a medium green and a medium red, are recorded on panchromatic black-and-white film, they appear as very similar shades of gray (see Macbeth ColorChecker below). When this happens, subjects and surfaces that are well differentiated in color now blend and lose their individuality, particularly if their textures are similar.

Polapan film, being panchromatic, allows the use of filters as a means of modifying black-and-white tonal relationships. Tones can be lightened or darkened, subtly or intensely, depending on the color of the filter and the color of the original object.

Filters traditionally used with conventional black-and-white film (strong reds, yellows, greens, etc.) produce identical effects when used with Polapan film. In general, a filter *lightens* those parts of the scene that are of its own or a similar color and *darkens* those that are of a complementary hue. For example, yellow filters lighten yellows and oranges and darken blues; red filters lighten reds and oranges and darken blues and greens. (See pages 70-73 for data on filters for all Polaroid instant 35mm films, along with tables that describe the effects of these filters.)

Certainly, filters are effective for dramatizing landscapes (e.g., darkening sky and water), but they are equally helpful for strongly separating subtle tonal differences in scientific subjects. Colored specimens, computer outputs, and works of art are frequently reproduced in journals or magazines in black and white. Photographing these subjects through filters prevents different colors from appearing as similar (confusing) shades of gray.

The Macbeth ColorChecker consists of 18 distinct colors and 6 shades of gray (see page 17). When recorded on a panchromatic black-and-white film such as Polapan, many of the colors reproduce as similar shades of gray.

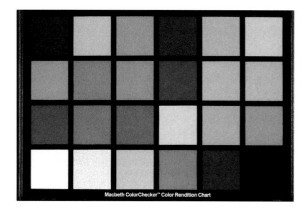

Dvorine Pseudo-Isochromatic plates are used to test for color blindness. Original plate consists of gray-dot numerals on background of red, salmon, and violet dots. Photograph on Polapan (*left*) creates image as seen by severely color-blind person. A Wratten #29 deep red filter lightens red-family background dots, leaving gray numerals in vivid relief (*right*).

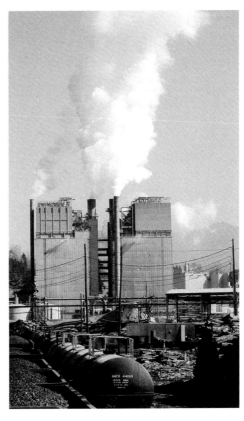
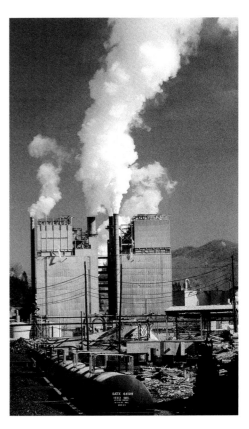

Blue skies tend to record too lightly on panchromatic black-and-white film (*left*) because the film is more sensitive to blue light than the human eye is and the sky tends to be significantly brighter than the subject. A Wratten #8 yellow filter provides a more normal tonal relationship (*center*). For very dramatic rendition, a Wratten #29 deep red filter was used with a polarizer (*right*). Filters do not darken overcast or cloud-covered skies.

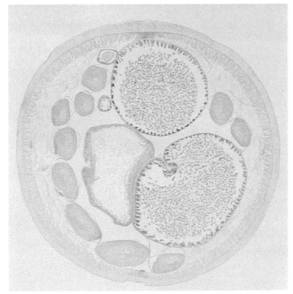
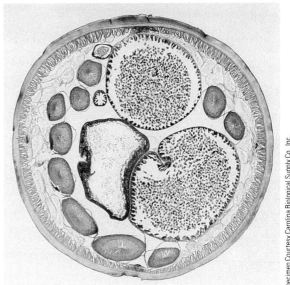

Cross section of female worm, *ascaris lumbricoides*, is stained various shades of magenta. Photographed without a filter on Polapan film (*left*), contrast is very weak. Contrast was greatly increased (*right*) by inserting two Wratten #11 yellowish-green filters in front of microscope light. (See page 62 for this photo in color.)

Polagraph film produces sharp, clear, black-and-white positive slides of high-contrast line art, such as titles, equations, graphs, engineering drawings, and typewritten copy.

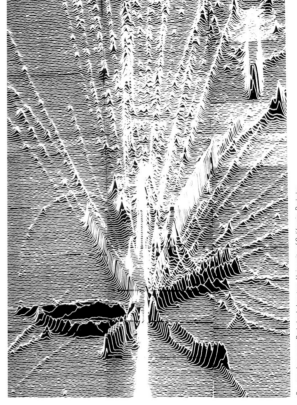

Courtesy Lawrence Berkeley Laboratory, University of California, Berkeley

Oscillograph traces, high-contrast computer graphics, topographic maps, and similar finely structured line plots become high-quality slides for lectures and seminars when copied on Polagraph film. Shown is a slide of a computer-enhanced streamer chamber photograph depicting high-energy collision of two atomic nuclei.

Polagraph high-contrast film can turn continuous tone subjects into very dramatic, graphic images. The effect can be achieved either by photographing the actual subject or by copying a continuous tone print or slide. The high speed of Polagraph (ISO 400/27°) permits use of small apertures, always desirable in close-up photography such as this silhouette of gears.

General description

Polagraph is a black-and-white, panchromatic 35mm film, packaged in 12-exposure cartridges, that produces high-contrast positive slides. The ISO is 400/27° for daylight and 320/26° for 3200K tungsten light. Polagraph film is processed in the Polaroid Auto-Processor using the processing pack supplied with each roll of film. *Development time for Polagraph film is 2 minutes, 60 seconds longer than for Polachrome or Polapan films.*

Polagraph film is intended primarily for making high-quality positive slides of line art, text, documents, drawings, charts, and similar graphic originals. Therefore, Polagraph slides usually contain no gray tones, just dense black image areas on a very clear base (base density is only 0.05).

However, with proper exposure, low-contrast subjects will be reproduced on Polagraph film with limited but distinct shades of gray. This effect, examples of which are shown below, can be beneficially used to substantially increase the tonal separation of very low contrast subjects, such as microscope specimens. Similarly, Polagraph film can be used to convert continuous tone subjects into striking, high-contrast positive graphics.

Image formation and development in Polagraph film are principally the same as in Polachrome film except that Polagraph film does not have the color filter stripes used in Polachrome. (See pages 18-19 for a detailed explanation of the image development process.)

Although Polapan film can be used to make slides of graphic originals (*far left*), Polagraph slides have a lower base density, more contrast, and therefore appear sharper (*left*), particularly if originals have weak blacks or backgrounds that are not clean white. These slides were photographed from a newspaper.

Polagraph film is not limited to recording high-contrast graphic originals. Low contrast and weak tonal separation frequently found in scientific subjects can also be improved significantly, enhancing the visibility of subtle details. Shown here is longitudinal section of a newborn mouse, photographed on Polapan (*right*) and on Polagraph (*far right*).

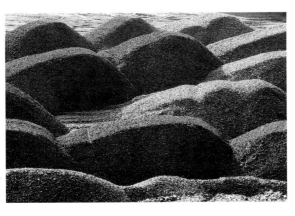
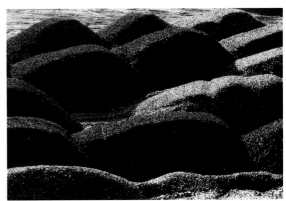

Polagraph film will convert continuous tone pictorial scenes into high-contrast graphic images, while retaining a limited range of gray tones. To compare medium-contrast film with high-contrast film, coal piles were photographed on Polapan (*right*) and on Polagraph (*far right*). Bracketing exposures by ⅓ stops was necessary to achieve proper results (see page 49).

Specimen Courtesy Carolina Biological Supply Co. Inc.

Additional technical information

Very low humidity

When exposed under very dry atmospheric conditions (less than 30% relative humidity), Polaroid 35mm film may curl slightly in the camera's film plane. To avoid any loss of resolution, use apertures of f/4 and smaller. (See page 20 for additional discussion.)

Off the film metering

Polachrome and Polapan film can be used successfully with most cameras that have off the film metering systems for electronic flash by using a compensated ISO setting. However, the compensation required for Polagraph film is beyond the range of most cameras. This should not be a problem because high-contrast films such as Polagraph are seldom used for the type of pictorial work that would require automatic flash metering. (When automatic flash exposure is necessary, the sensor *on the flash unit* can be used; see pages 74-77.)

Some cameras contain off the film systems for measuring *ambient* light. When exposure times with Polaroid 35mm films are longer than 1/60 second, those cameras should be switched to manual metering (see page 79).

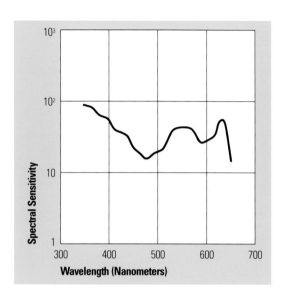

Spectral response of Polagraph film. Sensitivity is defined as reciprocal of exposure (ergs/cm^2) required to produce 0.5 visual density.

Brightness range and contrast

Shown below is a step tablet photographed on three high-contrast materials: Polagraph film, Kodak Precision Line Film LPD4, and Kodalith Ortho Film 6556, Type 3. (The first two are direct positive films, the third a negative-working material that requires a subsequent printing step to obtain positive images.)

A step tablet is a white-to-black array of gray patches used to simulate the brightness range of a scene. Each step is 1/3 stop lighter or darker than the step next to it. Compare the photographs of the step tablets for these high-contrast films with those on page 35 for continuous tone materials. The high-contrast photographs have a very limited brightness range, few gray tones, and large differences (contrast) between steps – qualities that produce the stark, graphic images characteristic of high-contrast films.

The step tablet photographs show that Polagraph is slightly less contrasty than the wet-processed films and has approximately a 1-stop longer brightness range and a correspondingly expanded gray scale.

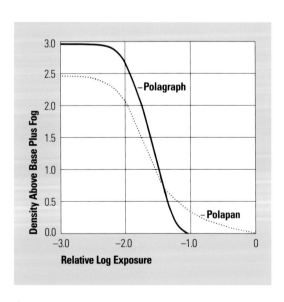

Characteristic curves of Polagraph and Polapan film. Corresponding base density and speed of both films have been equalized mathematically to allow comparison of curve shape.

Polagraph film

Kodak Precision Line LPD4

Kodalith 6556

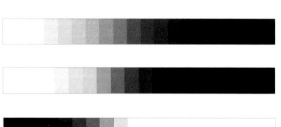

Special applications

Although Polagraph film is used primarily to photograph high-contrast line originals, it has additional applications in such fields as art, design, graphics, and audio-visual production.

For example, continuous tone photographs or artwork can be transformed into high-contrast, black-and-white images by photographing them with Polagraph film. No wet-processing or negative-to-positive steps are required. And because the film is panchromatic, this technique also can be used with full-color originals. If the resulting Polagraph slide contains unwanted gray tones, they can be dropped out by duplicating that slide on a second roll of Polagraph film.

When *prints* of such graphic conversions are required for layouts and composites, Polaroid instant prints can be made in a variety of convenient ways and sizes (see Chapter 11). Polagraph slides can also be converted quickly into clear base, overhead transparencies by using daylight-processed Polaroid Colorgraph transparency film Type 891 (see page 89).

Polagraph film can also be used to convert *positive* artwork (black lines on white background) into *negative* images (white lines against black background). This is done by first copying the artwork onto Polagraph film. The positive image is then inserted in a standard enlarger and projected onto conventional black-and-white enlarging paper. When processed, the print will be a negative representation of the original. (For further suggestions, see Chapters 10 and 11.)

Image is photograph of continuous tone color print. High-contrast, black-and-white rendition shown here was created by copying it onto Polagraph film.

Robert Keeling

Polagraph film is ideal for making slides of pen-and-ink drawings, engravings, and woodcuts. As with all high-contrast films, exposures must be accurate to prevent width of fine lines from expanding or contracting, thereby altering shading of artwork. Bracketing exposures is suggested.

Original artwork—black lines on white background—was copied onto Polagraph film. Positive slide was put in enlarger and projected onto conventional black-and-white enlarging paper, producing negative print (*above*). Negative print can be copied onto Polagraph to produce attractive white-on-black title slide. (For color variations on this technique, see pages 83 and 95.)

Permission of Candida Donadio & Associates Inc. © 1972 Edward Gorey

Graininess

When used for copying high-contrast, line art originals, Polagraph film exhibits virtually no graininess. White areas (clear film base) are completely free of grain; black lines appear solid and dense.

Graininess is more apparent when Polagraph film is used to photograph low-contrast, continuous tone scenes or artwork, particularly in the medium and dark gray areas. Of course, the appearance of grain depends on the magnification. For a projected slide, typical combinations of screen width and viewing distance create an image magnification of about 2X-4X for the observer. If the Polagraph slide contains gray tones, graininess at 2X-4X will be low. The same slide printed at 5X or larger will exhibit noticeable graininess.

▲ ▶
Hazy mountain scene was graphically enhanced by photographing it on Polagraph; film's high contrast helped differentiate receding "layers" of hills. Original slide (*above*) is reproduced at 2X. At 6X (*top right*) grain is apparent, particularly in medium and dark tones. Also shown is 10X enlargement (*bottom right*), about equivalent to 11 x 14 in. (30 x 40 cm) print.

Exposure

Small changes in exposure of high-contrast films produce relatively *large* changes in image density. Thus exposure latitude with high-contrast films is much more critical and unforgiving than with continuous tone emulsions.

A bracketed series of exposure tests is necessary to determine proper exposure with Polagraph film. When possible, use an 18% gray card for the meter reading to obtain the "nominal" exposure settings. Leave the camera set on manual, then bracket the exposures at least 1 full stop on either side of nominal, by ⅓ stops. The results can be used for subsequent work.

Before bracketing, the nominal exposure must be corrected for close-up lens extension, but only if through-the-lens metering was

not used, and only if the object distance is closer than eight times the lens focal length. If exposure times are longer than ⅛ second, correction must also be made for reciprocity failure (see Chapter 7).

Once correct exposure is established, results for a particular setup are repeatable. However, as noted, small changes in *exposure* will affect image density. Small exposure changes can be due to differences in the "whiteness" of the paper base of the artwork, voltage fluctuations and the age of copy lights, nonlinearities in lens apertures and/or shutter speeds, and failure to correct for lens extension when changing artwork on a copystand or when altering the magnification in close-up photography.

If meter reading is taken off subject, white background of typical artwork will lead to underexposure (*left*). Therefore, with camera set on manual, take reading from 18% gray card temporarily placed over artwork. This generally produces proper exposure (*right*), although additional corrections noted in text at left may be necessary.

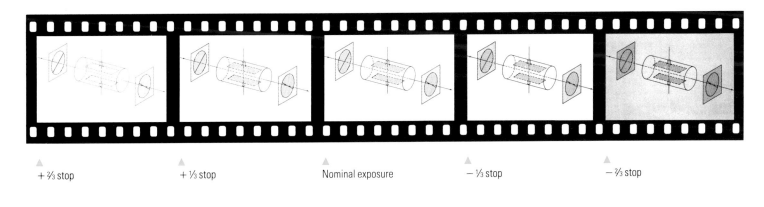

▲ + ⅔ stop ▲ + ⅓ stop ▲ Nominal exposure ▲ − ⅓ stop ▲ − ⅔ stop

Two exposure series (*above and right*) demonstrate that an aperture change of only ⅓ stop can significantly affect the appearance of Polagraph slides. When the subject is line art (*above*), slight overexposure causes lines to break up and wash out; underexposure quickly adds density to the background. Optimal results are achieved within ⅓ stop of the nominal exposure.

The appearance of continuous tone subjects (*right*) also changes noticeably with ⅓-stop exposure increments. In fact, because the brightness range of continuous tone subjects, such as this fossil specimen, varies more than line art subjects, continuous tone images require more bracketing to produce slides that have the desired combination of shadow and highlight details.

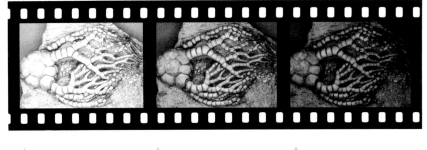

▲ + ⅓ stop ▲ Nominal exposure ▲ − ⅓ stop

Filters

Because Polagraph film is panchromatic (i.e., sensitive to the light of all colors), various filters can be used to strengthen or suppress black-and-white tonal differences in the photographs of colored subjects.

As with continuous tone black-and-white films, a filter used with Polagraph film will lighten its own color and darken its complementary hue. For example, a red filter will lighten red and darken blue, green, and cyan (cyan equals blue plus green). Similarly, a magenta filter will lighten magenta, blue, and red (magenta equals blue plus red) and darken green. (See page 73 for a table of these relationships.)

Because Polagraph is a high-contrast film, a particular filter generally has more of an effect on it than on a continuous tone film. However, when attempting to alter tones so that white areas appear light gray or black areas appear dark gray, weak colored filters may produce no noticeable effect.

Because color and tone factors vary greatly from scene to scene, tests are always recommended. If possible, use a variety of filters whose color saturation ranges from weak to strong. Additionally, bracket exposures by *at least* 1 stop on either side of the "nominal" exposure, in ⅓-stop increments.

Remember that when Polagraph film is used with 3200K tungsten lights, its ISO is 320/27°. In addition, as with all films, different emulsion batches may have slightly different ISO speed ratings.

Macbeth ColorChecker consists of 18 distinct colors, plus 6 shades of gray from white to black (*right*). When photographed on Polagraph (*far right*), colors that are similar in brightness record as equal, indistinguishable shades of gray. With many pairs of colors, tonal separation can be increased or decreased by using filters of appropriate colors.

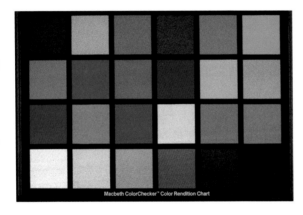
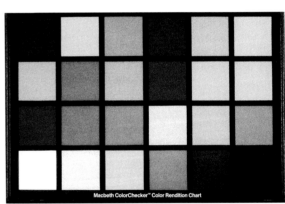

Very thin cross section of begonia stem, stained light cyan, showed weak visual contrast. Polagraph film was used to improve rendition of details (*right*) in photomicrograph at approximately 250X magnification. To further enhance contrast, a Wratten #29 deep red filter was used to darken faint areas (*far right*).

Oscillograph trace photographed on Polachrome film shows red plot against grid of brown and blue.

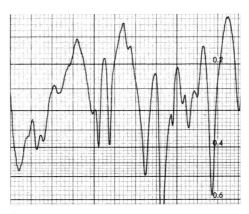

Same trace on Polagraph film is satisfactory, but fine grid lines give slide a cluttered look.

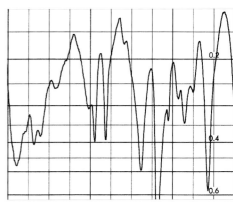

Polagraph film exposed through a Wratten #47 deep blue filter darkened red plot and dropped out blue grid.

Polachrome slide of computer graphic may be reproduced in black and white. To check tonality, Polachrome slide was copied on Polagraph film.

Unfiltered copy shows moderate tonal separation between white letters and vertical bars.

Use of a CC30R (reddish) color compensating filter darkened cyan bars, significantly increasing contrast between letters and bars.

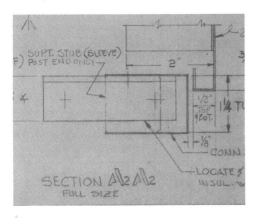

Blue line architectural drawing has weak contrast, as shown in this Polachrome slide.

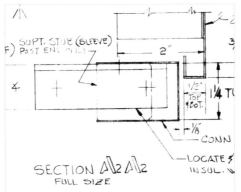

Polagraph slide has somewhat better visibility due to higher contrast of film.

Polagraph rendition is improved by photographing through a Wratten #16 yellow-orange filter, which darkens blue lines.

Polachrome slide shows vivid colors of computer-enhanced X-ray of broken ankle repaired with metal plate. Casually inspecting Polaroid 35mm slides in normal room light may not display the good image quality shown here. For proper evaluation, examine film on a light box with an opaque-base loupe or mount and project as slides.

Courtesy Artronics, Inc.

Initial evaluation

Polaroid 35mm instant films are designed primarily to produce slides for projection, and they look best when projected. Processed Polaroid 35mm film pulled from the cartridge and casually held up for initial inspection does not look like—*and should not be evaluated like*—conventional film.

This chapter describes simple but important techniques that should be applied to viewing Polaroid 35mm images, both before and during projection. In most cases, these techniques are only slight modifications of those recommended for optimal viewing of slides made with conventional film.

Rather than be disappointed with your slides because of improper viewing conditions, mount and *project* at least your first few rolls before making any evaluation.

The unique formulation of Polaroid 35mm films deposits silver as a mirror-like coating. When slides are viewed in their correct orientation, that silver faces you directly. Where the image consists of broad dark areas, such as the background behind the sunset moth, the deposit of silver will be heaviest (*right*).

Any overhead ambient light will reflect off the silver and compete with light coming through the film. This can produce strange effects. In this example with its dark background, the image looks like a negative. When projected or printed, the slide looks perfectly normal (*far right*).

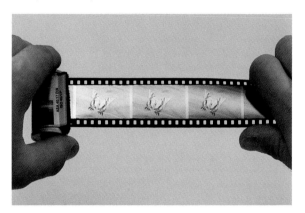

Specimen Courtesy Carolina Biological Supply Co., Inc.

Closely spaced red, green, and blue filter stripes in base of Polachrome film act as a diffraction grating, creating rainbow-like effects and misleading color casts when film is casually held up to small lamps or thin fluorescent light fixtures (*right*).

The best way to view a film strip is on an appropriate light box (see page 54). If this is not available, make a preliminary evaluation of Polachrome film by holding it up to a broad source of light, for example, a large, even fluorescent ceiling panel, sky, or large lamp shade. (These sources all have incorrect color balance; do not use them when making critical color decisions.) Also, block as much light as possible from the shiny, silver side of the film. (See page 60 for proper, scratch-free method of pulling film from cartridge.)

Strip of film that looked so poor when held up to a fluorescent tube (*above*) actually contains excellent slides (*right*). Specimen is a photomicrograph, about 200X, of a ranunculus root cross section.

Because base density of Polachrome film is approximately 2 stops higher than that of Polapan or Polagraph film, Polachrome slides have a higher ratio of reflected-to-transmitted light. This makes them more difficult to view under casual lighting conditions. The techniques discussed on the following pages will make evaluation easier and more accurate.

Light box viewing

A glass top light box containing fluorescent tubes is generally used to examine, edit, and mount slides. For all color transparencies, industry standards specify *full-spectrum* fluorescent tubes of 5500K color temperature. Other tubes can be used for black-and-white films, but they will probably impart a slight color cast to Polachrome film.

If Polachrome slides are to be used for projection, and if color balance is critical, then color evaluation should be made during projection, *not* on a light box. Slide projector bulbs typically have a 3300K color temperature. Their light is much "warmer" (more red and yellow) than a 5500K light box. Therefore, all color slides appear different when projected than when viewed on a light box.

Because Polachrome film is used primarily for projection, it is color balanced for viewing by 3350K illumination (standard Kodak Carousel projector bulbs). On the other hand, any critical evaluation of Polachrome slides intended for reproduction in magazines, books, and the like should be made on a 5500K light box (the printing industry standard). Or, you may have the printer alter the color balance when separations are made.

Similarly, slides which will be made into enlarged prints are ideally evaluated on a light box whose color temperature approximates that under which the prints will ultimately be viewed.

▷
Color quality of viewing illumination significantly affects apparent color balance of any color slide. Three portraits of a redhaired model with ruddy skin tones were exposed on Polachrome film under identical studio conditions and were filtered to simulate various viewing conditions.

A 5500K light box shows satisfactory skin tone (*right*). Light box

fitted with 25-watt bulbs has approximately 2600K color temperature; the slide now appears abnormally red-magenta (*center*). Holding slide up to clear blue sky (more than 10,000K) imparts very strong bluish cast (*far right*). Such differences are always more striking when shown side by side and may not be as apparent when slides are viewed individually.

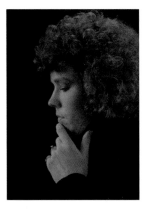
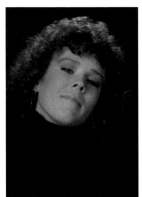

▷
Light striking silvery emulsion side of film lowers visual contrast, making images look muddy and underexposed. Effect is strongest with Polachrome film because of its high base density (*right*). Viewing contrast is easily improved by eliminating top lighting.

Even when overhead lights are turned off, some illumination from light box strikes surrounding surfaces and reflects back on top of film. Block that spill light with cardboard on either side of film; this also cuts down general glare, making viewing much easier (*far right*). Without cardboard, opaque-base magnifier (*opposite page*) similarly blocks reflected light when examining individual frames or slides.

Keep silvery emulsion side of film face *up* on light box. This orientation helps prevent scratching of emulsion. To further prevent abrasion, do not let magnifier touch emulsion surface.

Single tube fluorescent light strips, such as the type designed to illuminate counter tops below kitchen cabinets, make very effective light boxes. Inexpensive, portable, and readily available, their narrow width spills little extraneous, contrast-degrading light into a room. Cool white tubes provide better color than do warm white. Keep overhead lights turned off.

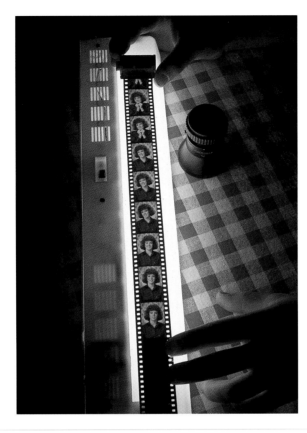

Transparent-base loupes (*above left*) scatter too much contrast-degrading light onto top of transparency. Black tape wrapped around skirt (*above right*) eliminates problem.

High-quality, opaque-base loupes that cover the entire 35mm frame are made by Emo (*shown*) and Schneider. Do not let loupe touch emulsion surface.

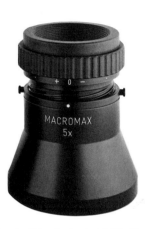

Comparing Polachrome slides to conventional slides

In a side-by-side comparison with conventional transparency materials, Polachrome film appears darker, lower in contrast, and weaker in color saturation (*below left*). These qualities are due to the higher base density, and therefore the lower relative brightness, of Polachrome film.

When slides are viewed or projected individually, in most cases your eye automatically compensates for the brightness difference, and both materials appear to have similar density, contrast, and saturation. When a Polachrome slide is printed, the effect of its higher base density is completely cancelled; even side by side, a print from Polachrome film looks as bright as one from conventional film.

If Polachrome and conventional slides must be compared directly for purposes of exposure or color balance, place a 0.5 or 0.6 neutral density filter (the latter is often called a 4XND) on top of or behind the conventional slide (*below right*). The slides will then have approximately equal brightness.

If Polachrome and conventional slides are intermixed in a slide presentation, their brightness differences may be noticeable. The differences are less apparent in a well-darkened room and more apparent when slides are changed rapidly. If brightness must be equal, 0.5 neutral density gelatin filters can be sandwiched in the mounts with the *conventional* slides.

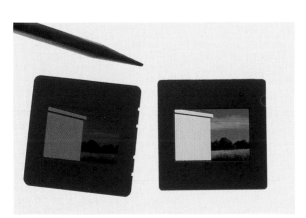

Polachrome slide (*left*), conventional slide (*right*)

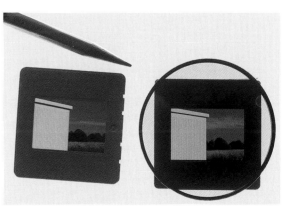

Polachrome slide (*left*), conventional slide with neutral density filter (*right*)

Slide mounts

Polaroid 35mm instant slides can be mounted in Polaroid 35mm slide mounts or in commercially available cardboard, plastic, or metal mounts (glass or glass-less). The silvery emulsion side of the film should face the lamp for front projection. For rear projection systems not employing mirrors, the silvery side must face the lens.

The rectangular opening in a Polaroid 35mm slide mount meets minimum industry standards and masks most artifacts that occasionally occur on the long edge of the film frame.

Some brands of mounts that have a slightly larger opening may not mask edge artifacts as well. If necessary, any visible ragged black edges can easily be removed (see page 60).

Projection conditions

There are a few simple ways to increase the projected image brightness of Polachrome slides when projection conditions are less than ideal. (Because the projected brightness of Polapan and Polagraph slides is very similar to that of conventional 35mm films, you can project them under the same conditions as you would conventional slides.)

Darken the room as much as possible, being particularly careful to prevent stray light from striking the screen. If the projector is equipped with a high-low switch, use the high setting. Make sure the projector's lens and internal condenser optics are clean. Use a screen rather than a white wall (see below). Select properly exposed slides.

When the screen is wider than approximately 7 ft. (2.1 m), and/or the room cannot be darkened properly, brightness can be increased substantially by installing a high-brightness bulb and switching from a zoom to a fixed-focal-length lens.

Sometimes an image is projected much larger than necessary, lowering its brightness. For example, a slide projected to a 5 ft. (1.5 m) width is twice as bright as when projected to a 7 ft. (2.1 m) width. You can decrease the image size by moving the projector closer to the screen or using a longer focal-length lens.

In large auditoriums, xenon-arc projectors can be used with all Polaroid 35mm instant slides. In areas such as offices, where ambient light is very high and where there are fewer than 12 viewers, consider using a compact rear-projection system such as the Bell & Howell RingMaster, Kodak AudioViewer, or Telex Caramate. These portable, self-contained units project a bright, 9 in. (23 cm) image that is not affected by ambient illumination.

Projector lenses

Changing the slide projector lens from a zoom to a fixed-focal-length optic is the best way to increase projected image brightness. Zoom lenses generally have f/3.5 apertures, fixed lenses have f/2.8 or f/2.5 apertures. Although this indicates a theoretical difference in light transmission of about 60% to 100%, actual measurements at the screen show that a fixed-focal-length lens typically produces 150% more brightness (averaged across the image) than does a zoom lens. Manufacturers of fixed-focal-length lenses designed to fit most popular slide projectors include Buhl, Kodak, Navitar, Schneider, and Tamron.

▲ Zoom lens (*left*), set at 5 in. (13 cm), is marked f/3.5. Five-inch (13 cm) prime lens (*right*) is labeled f/2.8, which is ⅔ stop faster. This lens actually provides more than 1 stop additional light at screen. Note large difference between lenses' pupils.

Projection screens

A glass-beaded screen offers the best balance between image brightness and viewing angle. Under normal circumstances, it provides much higher brightness than a matte screen or a white wall. Glass-beaded screens allow a broader viewing angle and have fewer surface wrinkles than lenticular screens.

When projected to certain specific sizes, the color stripes in Polachrome film may interact with the grooved surface of a lenticular screen and create a moiré pattern (wavy, roughly parallel bands) on the image. This pattern will occur only when the film stripes, which run parallel to the long dimension of the slide, are parallel with the screen grooves. To eliminate the pattern, change the image size slightly by moving the projector nearer to or farther from the screen, or, if possible, adjust the zoom lens focal length.

Dirty or dusty screens and screens yellowed by age can decrease image brightness considerably. Check with the screen manufacturer for cleaning directions.

Projector bulbs

High-brightness bulbs are available for most modern 35mm slide projectors. They typically increase screen brightness by about 30% when compared to the low brightness or standard bulb supplied with the projector. The life of a high-brightness bulb is about half that of a standard bulb. To obtain maximum illumination, put the projector's high-low switch in the high position. The bulbs in the table are recommended by the respective projector manufacturer; do not make bulb substitutions without first checking the instruction manual.

| Projector | Bulb brightness | | |
	Low	Standard	High
ELMO, Omnigraphic 300	ENH	ELH	ENG
KODAK, Carousel			
550, 570, 580, 600, 600K, 650, 700, 750, 760, 800, 850, 850-K, 860, AV900	DAH, DEA	DEK, CBA	na
600, 650H-K, 750H, 760H, 800H, 840H, 850H, 860H, 850H-K, 860H	ENH	ELH	ENG
4000, 4200, 4400, 4600, 5200, 5400, 5600	EXY	FHS	EXR
KODAK, Ektagraphic AF, B, E, RA-960	DAH, EGH, DEA	DEK, CBA	na
KODAK, Ektagraphic II AF-1, AF-2, AF-2K, AF-3, B2, B2AR, E-2	ENH	ELH	ENG
SA2000, S-AV2030, S-AV2050	Osram 64657	EHJ, Osram 64655	na
KODAK, Ektagraphic III A, AM, AS, AT, ATS, B, E, ES	FHS, EXY	EXR	EXW
LEITZ, Pradolux RT300, RT300AV	ENH	ELH	ENG
LEITZ, Pradovit 250, C2500, CA2500	Osram 64657	EHJ	na
150, R150, RA152, C1500, CA1500, RC, TA, N24	FDV	FCS	na
TELEX (formerly SINGER), Caramate 3120, 3130, 3150, 3170, 3230, 3260, 3270, 3280	ENH	ELH	ENG

na: not available

Projection fading

All color slides subjected to long periods of projection will eventually fade. Tests under typical projection conditions indicate that Polachrome slides can be projected two to five times longer than conventional (chromogenic) slide films before exhibiting a similar degree of fading.

A Polachrome slide projected continuously for 10 hours in a 300-watt projector showed a subtle visual change in some colors. After 20 hours the change was still small enough to be unnoticed unless directly compared to an identical, unprojected slide.

Because of this resistance to fading, Polachrome film is particularly recommended for slide shows and for continuously running point-of-purchase displays.

Photograph shows separation of strip sheet from developed film, which occurs inside Auto-Processor during rewinding. To ensure clean stripping, turn crank very fast when rewinding, about 3 to 4 turns per second.

Processing artifacts

Polaroid 35mm instant films, the processing packs, and the Auto-Processor are designed to function as a trouble-free, integrated system that produces clean, consistently developed slides. Most image defects can be traced to operator error usually caused by a lack of familiarity with correct processing procedures. Instructions for operating the AutoProcessor are given on pages 8-11.

Vertical lines in this example (*right*) were caused by "jerky" turning of the AutoProcessor crank during development (the first "cranking" step). The crank must be turned smoothly and evenly; starting and stopping causes the image defects shown. Brace the AutoProcessor firmly with your left hand while turning the crank with your right hand.

White spots on the film are usually caused by dirt or chemical residue on one or both stainless steel rollers in the AutoProcessor. Dirt on the rollers can prevent processing reagent from reaching portions of the film emulsion.

Although spots may be random, dirt that has adhered tightly to a roller produces a series of evenly spaced spots along the entire length of the film. Refer to page 61 for information on cleaning these rollers.

Streaks were caused by waiting too long (60 seconds) between lowering of the AutoProcessor control lever and turning of the crank. The correct procedure is to wait 5 seconds between these steps.

Lowering the control lever ruptures the chemical pod in the processing pack; a few seconds are required for the chemicals to funnel down onto the strip sheet.

Waiting less than 5 seconds after the pod ruptures can result in uneven development of the first few frames.

Similar streaks can be caused by pulling the developed film improperly from its cartridge (see page 60).

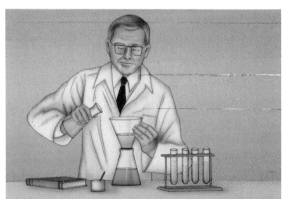

Shown here is frame 37 or 38 of a 36-exposure roll of Polachrome film. (Frame 13 or 14 of a 12-exposure roll would have the same appearance.) This type of image results if you attempt to take more than 36 (or 12) pictures on a roll.

Polaroid 35mm instant slide films are longer than conventional films. This extra length, which is needed for processing, ensures complete frames. Stop taking pictures when the camera's frame counter indicates 36 (or 12)—*not* when you feel the tension caused by the end of the roll.

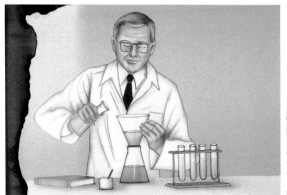

Illustration by Art and Kim Ellis

Edge artifacts

During the rewinding step, the black developer layer is stripped from the developed film. Occasionally, incomplete stripping occurs and bits and pieces of that layer are left on the film near the sprocket holes (*below right*). These black, ragged edges are easily removed, with no damage to the film or loss of image.

Certainly, it is best to prevent formation of these artifacts, if only to save time. Poor edge stripping can be avoided with

careful attention to certain procedures. Turn the AutoProcessor crank rapidly on rewind; do not stop or hesitate. If possible, process the film above 60°F (16°C). Let Polachrome and Polapan film develop for 60 seconds when the temperature is above 70°F (21°C) and for 2 minutes when it is below 70°F. Polagraph film should be developed for 2 minutes at all temperatures.

Pieces of developer layer can be removed at any time, and from

either a long strip or individual frames (first remove film from the slide mount). Lay the film on a clean, smooth surface, emulsion (silver) side up. With one hand, hold the film down *by the edges only*. Using the other hand, gently touch a piece of masking or transparent tape to the ragged black patch, then peel the tape up (*below left*). Be careful not to let the tape touch the image area. This procedure also

removes, without consequence, the black developer between the sprocket holes. The dotted line in the macrophoto of the red oak (*below right*) indicates an area stripped by tape. The image is completely unharmed.

If an edge is only slightly ragged on an unmounted film, there is probably no need to lift it off; all slide mounts crop a bit. But if 100% of the frame is required for printing, the edge stripping procedure should be performed.

Examining processed film

A major advantage of using Polaroid instant 35mm films is the opportunity to examine pictures immediately after processing without waiting for the film to dry. However, the emulsion side of instant film is more prone to scratching than is conventional film. You must take extra care when pulling the developed film from the cartridge.

To examine the film, hold the cartridge so that its felt lips point slightly upward (*below*). Pull the film out slowly, at a slight downward angle. This causes the film base—which is much less prone to scratching—to drag against the lower cartridge lip, relieving the more delicate emulsion side of most of the pressure from the upper lip.

To rewind the film into the cartridge, turn the protruding black shaft in a counterclockwise direction. Again, be certain to angle the cartridge so the film base (the glossy, nonsilver side) drags against the lower cartridge lip.

If the film will be stored in the cartridge, it is a good idea to keep the cartridge in its plastic canister. This prevents dirt from lodging on the felt lips and subsequently scratching the film. In humid conditions, the plastic canister also protects the film from excess humidity.

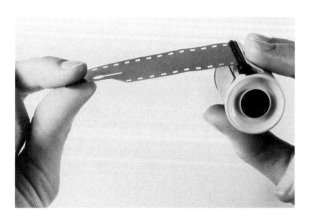

Processor maintenance

Dirt and chemical residue in the AutoProcessor can cause scratches and nasty artifacts on the film (see page 59). Simple maintenance and preventive measures will eliminate potential problems.

Outdoors and in dusty environments, store the AutoProcessor in a plastic bag. Also, keep the cover closed to prevent airborne dirt from entering the gears and from settling on the rollers.

Before each use, check all the areas shown at right that are highlighted in red. These include both stainless steel rollers in the cover, the metal plate under the area reserved for the processing pack, and the stainless steel roller near the front of the Auto-Processor. Rotate the rollers to inspect all sides. Remove any dirt or chemical residue with a damp cloth. Never scrape the rollers or metal plate with anything metallic or with your fingernail. *Also, always remove the processing pack immediately after development.*

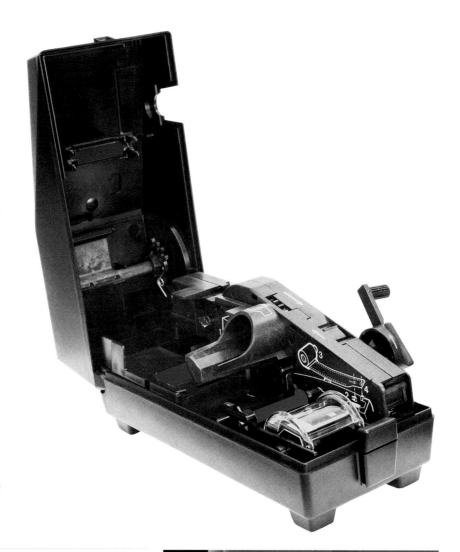

Film cleaning and scratches

Although scratches can occur during the developing process due to improper loading, or because of dirt and dust particles in the AutoProcessor, processing pack, or film, most scratches are caused by careless handling of the developed film.

At the right, for example, is a 3X enlargement of a Polachrome slide that was scratched when mounted slides were carelessly stacked. Slides handled frequently are best kept in glass mounts.

When examining newly developed film prior to mounting, keep these caveats in mind. Pull the film from and rewind it into the cartridge as described on page 60. Hold the film only by the edges. Always place the film on a light table, light box, or counter top with the emulsion (silver) side up. The light table or counter top must be clean; dirt that adheres

to the back of the film may scratch the emulsion side when it is rewound into the cartridge. Do not place a magnifier on the emulsion surface (a common cause of scratches); critical viewing of each image is best done *after* the slide is mounted, when the mount offers overall physical protection and prevents the magnifier from touching the film.

The best way to remove dirt and dust from the film is to use compressed air or a camel's hair brush. Brush the emulsion (silver) side *gently*; it is relatively soft and susceptible to abrasion, particularly when the relative humidity is high. Fingerprints and dirt can be removed from the base (nonsilver) side with lens tissue and water or film cleaner. Do not let the emulsion side come into contact with any of these liquids—the color balance may shift slightly.

High-contrast processing of Polachrome film

The processing pack supplied with each roll of Polaroid 35mm instant film produces the best balance between contrast, color fidelity, graininess, and film speed consistent with the general purpose use of each film type. However, by processing Polachrome film with the processing pack intended for Polagraph film, you can create color slides that have much higher contrast and color saturation than normally processed Polachrome film, with whiter whites which are ideal for title slides. (This technique will leave you with an unused Polachrome processing pack and unused roll of Polagraph film.)

Some subjects that can benefit from exaggerated contrast and color saturation include computer graphics, title slides, medical and biological specimens, and artwork such as graphs, charts, and technical illustrations. "Mismatching" the film and processing pack increases grain size and somewhat alters color rendition (see directly below). However, these drawbacks are generally unnoticeable and inconsequential.

Many of the exposure procedures for Polagraph film (described on pages 44-51) apply also to Polachrome film that will be processed in this way: exposure must be accurate to within 1/3 stop, exposure latitude is extremely limited, and exposure tests and bracketing by 1/3 stops are mandatory.

The overall color balance for whites and neutral hues remains about the same as for normally processed Polachrome film. Therefore, use daylight or electronic flash, or tungsten illumination with appropriate filters (see page 29). If high-contrast processing is used for Polachrome slides of video images, filtration may be necessary. For critical applications, tests are recommended.

Base the initial tests on a film ISO of 50/18°, and bracket exposures by 1/3 stops. If the exposure time exceeds 1/8 second, correct for reciprocity failure (see pages 66-69). When Polachrome film is processed with the Polagraph processing pack, develop it for 2 minutes.

Slides of Macbeth ColorChecker show contrast and color differences between normally processed Polachrome film (*right*) and Polachrome developed with processing pack from Polagraph film (*far right*). Developing time is 60 seconds for the normally processed Polachrome and 2 minutes for the Polachrome/Polagraph combination.

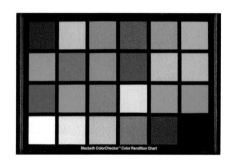 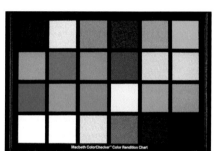

Microscope specimens frequently exhibit low contrast (*right*). Tonal separation, saturation, and visibility can be improved significantly (*far right*) by high-contrast processing of Polachrome. This example is a cross section of a female worm, *ascaris lumbriocoides*, photographed at 8X.

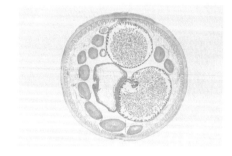 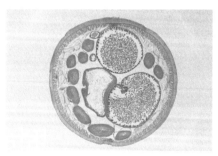

High-contrast processing of Polachrome is often appropriate when making slides of colored graphic or technical drawings. Colors will be bolder and more saturated, and white backgrounds will be cleaner and brighter. Slide at right is normally processed Polachrome, far right is high-contrast version.

 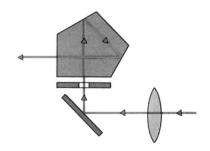

Processing time

At temperatures of 70°F (21°C) and above, process Polachrome and Polapan film for 60 seconds, Polagraph film for 2 minutes. At lower temperatures, process *all* films for 2 minutes. This time is measured from the completion of the initial turning of the crank to the start of the rewind cranking.

Lengthening the processing time does not affect the film speed or contrast. The step tablet photographs at the right show that even a fourfold increase in time makes no visual difference. *Shortening* the processing time does decrease contrast and film speed, but it also causes edge artifacts, uneven development, blotchy images, and low maximum density.

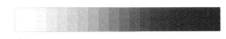

Polapan film processed for 30 sec.

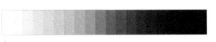

Polapan film processed for 60 sec.

Polapan film processed for 4 min.

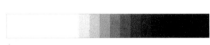

Polagraph film processed for 30 sec.

Polagraph film processed for 2 min.

Polagraph film processed for 4 min.

If you do not have a clock to accurately time the processing period, it is better to overestimate rather than underestimate the time. Increased processing time – up to 5 minutes – has no harmful effect on the image.

Altering the processing temperature can produce useful and repeatable changes in contrast. See below and pages 64-65 for details.

Processing temperature

Polaroid 35mm instant films can be exposed at any temperature; it is the *processing* temperature that is of concern. The best processing temperature is 70°F (21°C). Very good results can be obtained at 65°-80°F (18°-27°C), provided the processing time is extended to 2 minutes when the temperature is below 70°F(21°C).

If you are in doubt about the exact processing temperature, process the film for 2 minutes.

As the processing temperature falls below 70°F (21°C) image contrast begins to increase. At 60°F (16°C) this increase is quite noticeable (see next page). This higher contrast is acceptable – if not desirable – for certain subjects.

When processing below 70°F (21°C) you may encounter incomplete stripping of the negative layer from the developed film. This can be minimized if you turn the crank very fast during rewind and *extend the processing time to 2 minutes*.

As the processing temperature rises above 70°F (21°C), the fog level gradually begins to increase while maximum density and image contrast decrease.

If the processing pack or exposed film has been stored in a hot or cold environment, allow time for it to reach the proper temperature before processing. One hour is sufficient for a 30°F (17°C) change.

This pair of test photos clearly shows the effect of processing Polachrome film at a very high temperature. Two rolls were exposed at ambient temperature of 90°F (32°C). One roll was processed in the evening after temperature dropped to 72°F (22°C). These slides (*right*) have good contrast, strong color saturation, and clean highlights. The other roll was processed immediately at 90°F (32°C); these slides (*far right*) show the effect of extremely high processing temperature: noticeable fog and lower color saturation, contrast, and maximum density.

Processing temperature, continued

Polaroid 35mm instant films are often used in locations where the temperature cannot be controlled or under field conditions, as test materials to check exposure, composition, and operation of equipment. In these situations, temperatures often fall outside the range recommended for film processing. For these cases, the need for rapid test results or darkroom-free processing outweighs image quality considerations.

If the resulting changes in contrast and density are acceptable, all three films can be processed at temperatures as low as 50°F (10°C) or as high as 100°F (38°C). If you process the film below 65°F (18°C) or above 80°F (27°C), base your exposure on the modified ISO settings listed in the table on

page 65. At processing temperatures of 70°F (21°C) and below, remember to process *all* films for 2 minutes and turn the crank briskly both initially and during rewind. Examples of the effects of processing temperature on Polapan film are shown below; a similar series for Polachrome film appears on the opposite page.

High-temperature processing increases the fog level. Compared to film processed at normal temperatures, the minimum density areas (white parts of the image) will have higher density and appear slightly grayish. Similarly, the maximum density areas (blacks and very dark tones) decrease in density, making slides appear less sharp and less contrasty.

For pictorial photography, the increased fog level and lower maximum density that accompany high-temperature processing may be unacceptable. But for technical or commercial subjects that have extreme contrast and brightness ranges, the lower contrast produced by high-temperature processing can be advantageous.

When processing temperatures can be accurately controlled, as in a laboratory incubator or refrigerator, image contrast can be modified *intentionally* by processing above 80°F (27°C) or below 65°F (18°C).

For example, when photographing low-contrast medical and biological subjects, increasing the film's contrast can often improve the rendition of detail. Processing Polachrome film at 60°F (16°C) noticeably increases

its contrast without significantly changing its color balance. Processing at 50°F (10°C) increases contrast even more, although bits of the negative layer may have to be peeled manually from the film edge (see page 60).

The contrast of Polachrome slides can also be increased by processing the film with the Polagraph processing pack (see page 62). However, with cold temperature processing you have more control over the degree of contrast increase, colors remain fairly accurate, graininess is not as high, and no special processing pack is required. Polapan film also can be processed at lower temperatures for greater contrast. (Contrast will not be as high as that of Polagraph film, however.)

Polapan film processed at 50°F/ 10°C (*right*); processed at 70°F/ 21°C (*far right*).

Processed at 90°F/32°C (*right*); processed at 100°F/ 38°C (*far right*).

 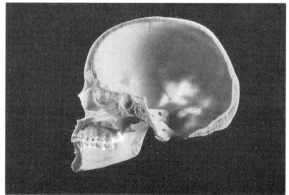

Modified film speeds if film will be processed at higher or lower temperatures

Processing temperature	Polachrome film		Polapan film		Polagraph film	
	Daylight	Tungsten*	Daylight	Tungsten	Daylight	Tungsten
100°F (38°C)	64/19°	50/18°	250/25°	160/23°	Not recommended	
90°F (32°C)	50/18°	40/17°	250/25°	160/23°	320/26°	250/25°
80°F (27°C)	50/18°	40/17°	160/23°	100/21°	320/26°	250/25°
70°F (21°C)**	40/17°	32/16°	125/22°	80/20°	400/27°	320/26°
60°F (16°C)	50/18°	40/17°	125/22°	80/20°	400/27°	320/26°
50°F (10°C)	64/19°	50/18°	160/23°	100/21°	500/28°	400/27°
40°F (4°C)	64/19°	50/18°	200/24°	125/22°	500/28°	400/27°

*Use these film speeds when no tungsten-to-daylight filter is used. With a filter and through-the-lens metering, use the daylight speeds.

**Optimum processing temperature. Remember to process all films for 2 minutes when processing below this temperature.

▷ Polachrome film processed at 50°F/10°C (*right*); processed at 60°F/16°C (*far right*).

▷ Processed at 70°F/21°C (*right*); processed at 80°F/27°C (*far right*).

▷ Processed at 90°F/32°C (*right*); processed at 100°F/38°C (*far right*).

Illumination level in Dartmouth College building (closed for the night) was extremely low. With f/16 aperture chosen to ensure sharp focus from foreground to background, exposure meter indicated corresponding shutter speed of 90 seconds for Polapan film. However, correction for reciprocity failure required *actual* exposure time of almost 35 minutes.

Definition

The law of exposure reciprocity, E (exposure) $=$ I (illumination intensity on the film) x T (exposure time), says that a long exposure with a small lens aperture will produce the same film density as a shorter exposure with a proportionally larger aperture. For example, $1/125$ second at f/8 produces the same exposure as $1/60$ second at f/11, or $1/250$ second at f/5.6. Between exposure times of about $1/1000$ second and $1/15$ second, the reciprocity law holds for most films.

However, when any film is exposed to a low intensity of illumination for a much longer time than its design warrants, under-exposure results. For most conventional films, this effect, called the failure of the reciprocity law, becomes noticeable at exposure times anywhere from $1/15$ second to 1 second and longer. This characteristic of photographic emulsions is easily corrected by increasing the meter-indicated exposure, either by lengthening the exposure time or by using a larger lens aperture.

Underexposure due to reciprocity failure may also occur at high levels of illumination when exposure time is unusually short. This too can be corrected by increasing the exposure time or opening the lens aperture. However, Polaroid 35mm films show no appreciable reciprocity failure between $1/15$ second and $1/100,000$ second, and therefore require no exposure correction within that range.

Most exposure meters are calibrated without correction for reciprocity failure. Therefore, when the meter-indicated exposure time falls within the range of reciprocity failure indicated by the film manufacturer, that meter-indicated exposure must be increased.

For example, with a camera mounted on a copystand, a typical meter reading for Polachrome film might indicate 1 second at f/16. The table on page 69 shows that properly exposed slides actually require either 1 second at f/11 or 3 seconds at f/16.

Electronic flash with a duration of only $1/30,000$ second was used to freeze the fall and splatter of a raw egg.

Photography of high-speed transient events usually requires test exposures, and Polaroid 35mm instant films are ideal for this purpose. Polaroid 35mm films have virtually no high-intensity reciprocity failure at exposures as short as $1/100,000$ second – unlike conventional films. Before using these tests results for conventional films, check the conventional film specifications and increase exposure as needed.

Compensating for reciprocity failure

Reciprocity failure can be corrected by either opening the lens or by increasing the exposure time. However, compensating for reciprocity failure through a time increase is always *more* than correcting it through an aperture increase. This is because low-intensity reciprocity failure is compounded by every increase in exposure time.

Therefore, in very low light-level situations, exposure times can extend to many minutes. To avoid inordinately long exposures, try to correct for at least part of the reciprocity failure by opening the lens aperture. There are situations, such as in photomicrography, where the aperture cannot be adjusted, or where a smaller lens aperture is needed for depth-of-field or lens resolu-

tion requirements. In such cases, try to increase the intensity of illumination. If constraints dictate very long exposure times, be sure to eliminate any source of vibration in the camera or subject that could blur the image.

When using Polachrome film, remember that it is *not* necessary to add color correction filters for reciprocity failure, because

unlike conventional film, Polachrome does not show a color shift with long exposures (see page 20).

Do not dismiss the need for correction of reciprocity failure. Even at a meter-indicated exposure time of ½ second, the correction for reciprocity failure of Polaroid 35mm films is 1 stop – a very noticeable difference in any transparency film.

Exposure meter indicated 2 seconds at f/16 for this dimly lit scene photographed at dusk on Polapan film. Exposure meters do *not* compensate for low-intensity reciprocity failure inherent in all films. This exposure was not corrected for reciprocity failure and slide is 1⅓ stops underexposed. (Black shaft in center is silhouette of tree trunk.)

To correct for reciprocity failure in a 2-second exposure, lens should be opened 1⅓ stops. Scene photographed for 2 seconds at f/10 instead of f/16 is now properly exposed.

When shutter speeds longer than ⅛ second are used on automatic cameras, set exposure compensation control to "overexpose" amount required for reciprocity failure correction. Alternatively, use camera's meter to obtain a basic exposure reading, then set camera to "Manual" and alter aperture or shutter speed as required.

Specimen courtesy Carolina Biological Supply Co. Inc.

Giant metallic leaf beetle (*Sagrinae*, male) was photographed at 0.5X magnification on Polachrome film with tungsten lights, using Wratten #80A filter.

For f/22 aperture, camera's through-the-lens meter indicated 6-second exposure. Severe underexposure was caused by not correcting for reciprocity failure.

Correction for reciprocity failure lengthened exposure to 35 seconds at f/22 but still produced excellent results. No additional filters were required.

Correction for reciprocity failure

Note: These are suggested corrections for obtaining proper highlight exposure; for critical use, exposure tests should be made.
*Take meter reading from medium tone area in scene. When using Polagraph film to photograph high-contrast subjects, take reading from an 18% gray card.
**These times will provide clean whites in Polagraph slides of high-contrast graphic originals. When Polagraph film is used to photograph continuous tone subjects, use the exposure times suggested for Polachrome and Polapan film.

Meter-indicated exposure time* (sec.)	Open lens — All Polaroid 35mm films	or	Use this exposure time — Polachrome and Polapan	Polagraph**
1/100,000 – 1/15	No correction required		No correction required	No correction required
1/8	1/3 stop		—	—
1/4	2/3 stop		1/2 sec.	1/2 sec.
1/2	1 stop		1 sec.	1 sec.
1	1 stop		3 sec.	3 sec.
2	1 1/3 stops		6 sec.	8 sec.
4	1 2/3 stops		20 sec.	24 sec.
8	2 stops		60 sec.	66 sec.
16	2 1/3 stops		2 1/2 min.	4 min.
32	2 2/3 stops		10 min.	13 min.
64	3 stops		24 min.	36 min.

Image alterations created by special effects filters can be quickly evaluated by using Polaroid 35mm instant films. Here, for example, Polapan film was used to determine which of several fog filters was appropriate for "mysterious" ambience. This exposure was made through a Tiffen #5 fog filter.

8 Filter factors and special applications

Filter factors

Some of the light falling on a filter is absorbed and/or reflected; the balance is transmitted to the film. Photographers are concerned with the amount of light transmitted and the degree to which the exposure must be increased when the filter is used.

The *filter factor* indicates the exposure increase required to reproduce whites, grays, and blacks in the scene with the same density they would have on film without the filter.

Filter factors take into account the type of light. Daylight is rich in blue and relatively weak in red; the opposite is true of tungsten light. Separate factors are therefore provided for the two types of illumination.

Cameras with through-the-lens meters will automatically compensate for the light loss caused by a filter on the lens. Therefore, with cameras that have through-the-lens meters, do *not* apply any correction filter factor. However, due to the differences in the spectral response of films and light meter cells to various sources of light, bracketing the exposures is recommended, particularly when using a high-contrast film such as Polagraph.

When exposure readings are taken with handheld meters or with other systems that do not measure light coming through the lens, the filter factors in the table below must be applied to the basic exposure reading.

The table can be used in any of four ways.

1
The exposure time can be multiplied by the filter factor. For example, a filter factor of 4 requires that an exposure of $\frac{1}{250}$ second at f/4 be increased to $\frac{1}{60}$ second at f/4.

2
The film's ISO speed can be divided by the filter factor and the ISO setting on the meter changed. Thus, a filter factor of 4 would lower a film speed of ISO 400 to ISO 100.

3
The lens can be opened by the filter factor's equivalent in f-stops, shown in parentheses in the table. The filter factor of 4 is equivalent to 2 stops; an exposure of $\frac{1}{250}$ second at f/16 would thus be increased to $\frac{1}{250}$ second at f/8.

4
Alternatively, the exposure increase could be a combination of a longer exposure time and larger lens aperture. Correct for reciprocity failure when exposure times exceed $\frac{1}{8}$ second.

Filter factors

Filter (Wratten no.)	Color	Polachrome film		Polapan film		Polagraph film	
		Daylight	Tungsten	Daylight	Tungsten	Daylight	Tungsten
1A (Skylight)	Pale pink	1 (0)	1 (0)	1 (0)	1 (0)	1 (0)	1 (0)
8	Yellow			1.6 (⅔)	1.3 (⅓)	1.6 (⅔)	1.3 (⅓)
12	Deep yellow			1.6 (⅔)	1.3 (⅓)	1.6 (⅔)	1.3 (⅓)
15	Deep yellow			2.0 (1)	1.6 (⅔)	1.6 (⅔)	1.3 (⅓)
23A	Light red			4.0 (2)	2.5 (1⅓)	3.2 (1⅔)	2.0 (1)
25	Red			6.3 (2⅔)	4.0 (2)	4.0 (2)	2.5 (1⅓)
29	Deep red			8.0 (3)	5.0 (2⅓)	5.0 (2⅓)	3.2 (1⅔)
32	Deep magenta			2.5 (1⅓)	2.5 (1⅓)	2.5 (1⅓)	2.0 (1)
44A	Light blue-green			13 (3⅔)	16 (4)	13 (3⅔)	20 (4⅓)
47B	Deep blue			6.3 (2⅔)	13 (3⅔)	8.0 (3)	16 (4)
61	Deep green			6.3 (2⅔)	6.3 (2⅔)	6.3 (2⅔)	6.3 (2⅔)
80A	Blue-conversion		3.2 (1⅔)				
80B	Blue-conversion		2.5 (1⅓)				
81A	Yellow-warming	1.3 (⅓)	1.3 (⅓)				
81B	Yellow-warming	1.3 (⅓)	1.3 (⅓)				
81C	Yellow-warming	1.6 (⅔)	1.6 (⅔)				
82A	Blue-cooling	1.3 (⅓)	1.3 (⅓)				
82B	Blue-cooling	1.6 (⅔)	1.6 (⅔)				
Polarizing		2.5 (1⅓)	2.5 (1⅓)	2.5 (1⅓)	2.5 (1⅓)	2.5 (1⅓)	2.5 (1⅓)

Apply these filter factors only to exposure readings taken *without* through-the-lens meters. Numbers in parentheses are equivalent corrections in f-stops.

Special applications

Filters for close-up photography

When a filter is used in close-up photography, it decreases image sharpness if attached to the lens *after* focusing. Therefore, attach any filters prior to focusing. As an alternative, consider filtering the light source, eliminating the need for focus adjustment.

The need to focus through the filter is of concern at magnifications about 0.3X and greater. Glass filters, which are relatively thick, cause much more of a focus shift than thinner gelatin filters; large apertures show filter-caused focus shift more than small apertures. For copy work on a stand fitted with tungsten lights, daylight-balanced

Polachrome film requires a conversion filter. If the original is smaller than the size of a postcard, focusing through the filter ensures maximum sharpness.

Polarizing filters

Polarizers are among the few filters that can be used with both black-and-white and color film.

They reduce the glare and reflections from glass, water, and non-metallic surfaces, but only if the lens is at the correct angle to the surface. For example, if the lens is at a 90° angle to a pane of glass, a polarizing filter will not reduce the reflections of the camera or the photographer in the glass.

Polapan slide of chick embryo lacks contrast due to translucent, light-tone of pinkish specimen. Camera magnification was 5X.

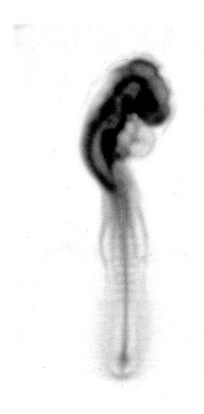

Wratten #61 deep green glass filter greatly improved contrast, but image is terribly blurred because filter was attached to lens after focusing.

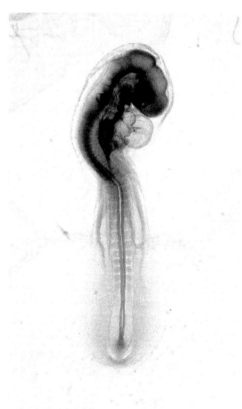

By focusing after filter was mounted, sharpness was retained along with benefits of increased contrast. Thin (gelatin) filters add less optical aberration than thick (glass) filters.

Specimen Courtesy Carolina Biological Supply Co., Inc.

Polarizing filters darken blue skies dramatically (they have no effect on totally cloudy skies). When used for this purpose, dark sky biased through-the-lens meter and caused overexposure (*right*).

To retain darkened sky, set camera to manual mode. Take exposure reading with polarizer on lens but rotated for no polarizing effect. With that reading, rotate polarizer for maximum sky-darkening effect (*far right*) and then expose film. Both Polachrome slides of Vermont meeting hall were taken with polarizer set in identical position.

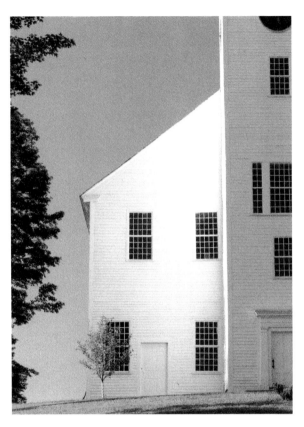
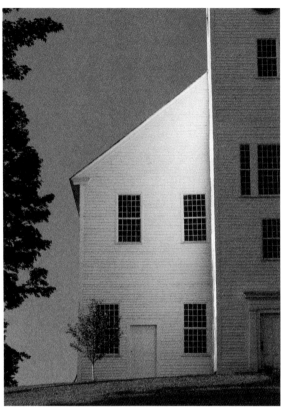

Filters for Polapan and Polagraph film

Polapan and Polagraph films convert colored subjects into images that consist of white, black, and various shades of gray. You can change the way these tonal values are derived from colors in the scene by photographing through a filter (see examples on pages 42, 43, and 51).

A tone can be lightened in relation to other tones in the scene by using a filter that is in the same color family as the subject. (For example, a greenish filter will cause green trees and grass in a scene to appear lighter.) Conversely, a tone can be darkened by using a filter whose color is the complement of the subject's color. (A yellow filter will make a blue sky appear darker, for example.)

This table lists common filters and the effects they will have on various colors. These suggestions are starting points only; results will depend very much on the exact color of the subject. For critical applications, tests should be performed.

Subject color (complement)	Filters to lighten subject			Filters to darken subject		
	A little	Moderately	Strongly	A little	Moderately	Strongly
Red (cyan)	23A	25	29	38A	44A	45
Green (magenta)	59A	56	61	30	31	32, 36
Blue (yellow)	38	38A	47B, 49	8	12	21
Magenta (green)	30	31	32, 36	59A	56	61
Cyan (red)	38A	44A	45	21, 23A	25	29
Yellow (blue)	8	12	21	38	38A	47, 47B

All filter numbers refer to Kodak Wratten filters, or equivalent. When two filters are listed, the second one will produce a stronger effect.

Tulip was photographed on Pola-chrome film using ring flash controlled by camera with off the film metering. To achieve proper exposure with these flash metering systems, ISO dial on camera must be set higher than true speed of Polaroid 35mm film. You can avoid this procedure by using automatic sensor found on almost all portable flash units.

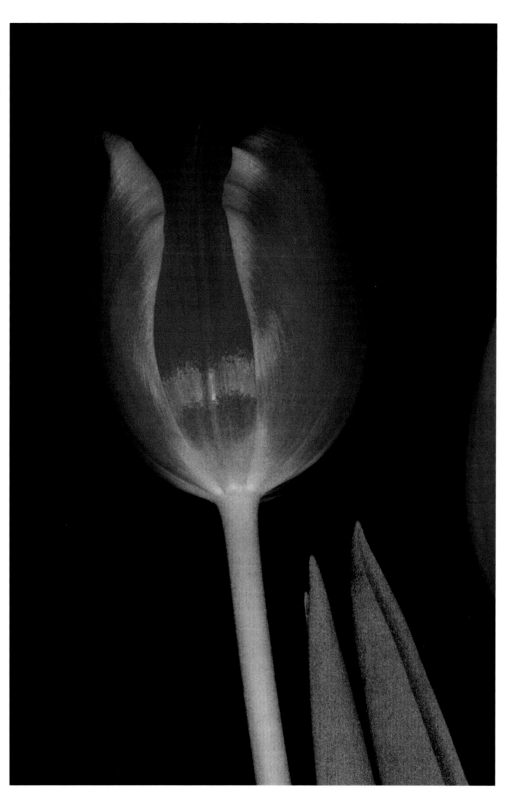

Electronic flash

The general techniques used for flash photography with conventional films also apply to Polaroid 35mm instant films. In fact, the difficulties associated with flash photography – visualization of lighting patterns and ratios, exposure calibration and equipment operation – make the instant testing abilities of Polaroid 35mm film particularly useful for work involving either portable or studio flash.

There is one important difference, but it is of concern only when using automatic flash exposure systems that measure light reflected *off the film*. Off the film meters are calibrated for light reflecting off the light gray, dull-finished emulsions of conventional film. Polaroid 35mm films have a black surface facing the camera lens. This surface reflects light away from the cells of off the film meters.

There are two methods available when using cameras with off the film meters. The first is to bypass the off the film sensor inside the camera and use the built-in sensor *on the flash unit itself*. (Most automatic flash units, even the so-called "dedi-cated" flashes, have built-in sensors.) When the sensor on the flash is used, the exposure is not affected by the reflectivity of the film.

With the second method the off the film meter in almost all cameras can be used, but the camera's film speed dial is set at a *compensated* ISO, not at the actual film speed (see pages 77-79).

For cameras that do not have off the film flash metering, there are no special concerns when using Polaroid 35mm films. Even though a camera has through-the-lens (TTL) *ambient light* metering, and most 35mm single lens reflex cameras do, this does not necessarily mean it also has off the film *flash* metering. Check the instruction manual supplied with your camera to determine if the flash light is actually metered *off the film*. If it is, read the instructions on the next four pages.

When using a handheld meter or the guide number system to determine flash exposure, treat Polaroid 35mm films like conventional materials.

There are two types of automatic flash exposure systems. Both have sensors that measure light reflected back from subject – the difference is where sensor is located. Flash systems with sensors *on the flash unit* measure reflected light directly *(right)*. Systems where sensor is *inside the camera* (called "off the film" systems) usually measure reflected light *after* it bounces off the film *(far right)*. When Polaroid 35mm films are used with off the film systems, special ISO settings are necessary.

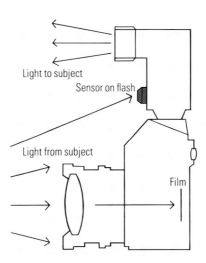
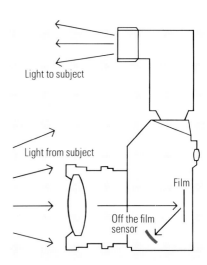

Light to subject

Sensor on flash

Light from subject

Film

Light to subject

Light from subject

Off the film sensor

Film

Off the film flash metering systems can produce overexposed slides with Polaroid 35mm films *(right)*. These same systems produce properly exposed slides *(far right)* when film speed dial is set to *compensated* ISO value.

Automatic flash photography using sensor on flash unit

For general automatic flash photography, it is recommended that you use the exposure sensor *on the flash*, rather than the off the film flash metering system in the camera (if it is so equipped). This will eliminate the need to set the camera to a special compensated film speed (see opposite page), which, in turn, must be reset to the normal value whenever non-flash pictures are taken.

When using the flash unit's automatic exposure sensor with Polaroid 35mm film, all settings and operations are identical to those for conventional film. Set the camera on "Manual" and its shutter to the proper manual flash-sync speed, which is typically 1/60 or 1/125 second (check your camera manual). *Do not set the camera on "Automatic" or "Program."* If the flash has separate settings for "Automatic" and "TTL" (or "OTF"), use "Automatic." Next set the flash to the *normal* ISO value for the Polaroid 35mm film in use. The scale on the flash will then indicate a choice of lens apertures and corresponding distance ranges.

There are a few cameras that have through-the-lens flash metering systems that do *not* measure light reflected off the film. Operate these cameras with Polaroid 35mm film as you would with conventional film.

Pencil points to typical sensor found on front of most camera-mounted flash units, including units "dedicated' to a particular camera model. For general flash photography with Polaroid 35mm films, these sensors will produce properly exposed images without special settings. The few dedicated flash units lacking this sensor require use of camera's off the film metering system (see opposite page).

When sensor on *flash* controls automatic flash exposure, set camera *(right)* to proper *manual* flash-sync shutter speed (refer to your camera instructions). Flash units that operate with their own sensor or sensor in camera have a selection switch that should be set to "Automatic" *(far right)*.

Automatic flash sensor ensures proper exposure within a particular distance range and for each allowed lens aperture. Underexposure occurs when subject is farther away than recommended, overexposure when too close. Scale on relatively powerful flash unit *(right)* shows that its range with Polachrome film ("ASA 40") is 3.1 to 18 ft. (0.9 to 5.5 m) at f/4. Smaller flash unit *(far right)* indicates only 2 to 12 ft. (0.6 to 3.5 m) for same film and aperture.

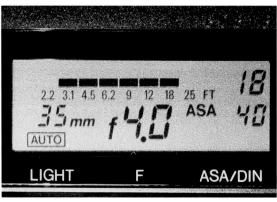

Small, camera-mounted flash units have relatively close ranges, particularly with slow lenses. Basketball fans were photographed on Polapan film with wide-open f/4.5 zoom lens set at 110 mm. Distance of 18 ft. (5.5 m) caused underexposure.

Zooming to 80 mm focal length and moving in to about 6 ft. (1.5 m) brought subjects well within range of flash and even allowed f/8 aperture for good depth of field. Check flash instructions for distance range at each aperture.

Automatic flash photography using off the film sensor

A flash sensor located inside a camera measures the amount of light actually transmitted by the lens. These exposure systems provide flexibility in aperture selection and are easier to use for close-ups and multiple flash work, photography with extreme wide-angle or telephoto lenses, and photography when filters are used over the camera lens.

Some through-the-lens flash metering systems measure the light *before* it strikes the film.

When used with Polaroid 35mm film, these cameras should be operated in the same manner as when using conventional film. However, most through-the-lens flash metering systems measure the light reflected off the film surface at the time of exposure. These systems will provide proper exposure with Polaroid 35mm films if the camera and flash controls are set as follows.

Set the *camera* to "Automatic" (do not use "Program" even if it is available). Adjust the camera's

ISO dial to the compensated value listed on page 78. Next, set the "Automatic/TTL" (or "OTF") switch on the flash unit to "TTL" (or "OTF"). Set the ISO dial on the flash to the *true* speed of the Polaroid 35mm film in use, and use the scale on the flash unit to determine the flash-to-subject distance range for each lens aperture. These distances are based on the true ISO film speed, not the compensated value.

Remember to reset the camera's ISO dial to the film's true speed when flash photography has been completed.

When using the compensated ISO speed, very high ambient light conditions or a bright light source in your scene (such as a lamp or outside light through a window) may interfere with the operation of the off the film metering cell. Some cameras may not trigger the flash. Therefore, for these scenes use the sensor on the flash (see pages 75-76).

When using sensor inside camera to control automatic flash exposure, set flash unit *(right)* to "TTL" (or "OTF"), and set camera *(far right)* to "Automatic." Do *not* use camera's "Program" mode when using a compensated ISO speed.

ISO dial (*right*) on camera must be set to *compensated* ISO speed when off the film flash metering system is used with Polaroid 35mm films. However, set flash calculator scale (*far right*) to *true* film speed. Scale then indicates correct distance range.

Bounce flash provides soft illumination (*right*). With small flash units it should be restricted to flash-to-ceiling-to-subject distances of 15 ft. (4.5 m) or less when using Polachrome film. With Polapan film, maximum bounce distance increases to about 20 ft. (6 m). To prevent underexposure, use large apertures such as f/2 and f/2.8. These suggestions apply when using light sensor either on flash unit or in camera.

Compensated ISO settings for off the film flash metering

The table below lists suggested compensated ISO settings for the camera's ISO dial when using off the film flash metering with Polachrome and Polapan film. (When using Polagraph film, use the sensor on the flash unit; set the camera and flash unit as directed on page 76.)

Use these values as starting points only. If your slides are consistently overexposed, increase these suggested values; if consistently underexposed, decrease them.

	Set ISO dial on camera to this compensated speed	
Camera	Polachrome film	Polapan film
Minolta X-700	320	1,000
Nikon F3	Use sensor on flash	Use sensor on flash
FA	320	1,000
FE2	800	2,500
FG	1,250	3,200
Nikonos V	160	500
Olympus OM-2N	200	640
OM-4	200	640
Pentax LX	200	640
Super Program	125	400

Use the *true* film speed settings when using either the sensor on the flash or through-the-lens flash meters that do *not* read reflected light off the film.

Close-up photography can bene-fit from through-the-lens flash metering. Frog was photo-graphed using multiple flash setup controlled by camera's off the film flash metering system. This particular camera required compensated ISO of 200 with Polachrome film.

Polaroid 35mm films are particularly useful for testing unusual flash techniques. If test exposure results with Pola-chrome or Polapan film are to be extrapolated for exposing con-ventional film, use *true* ISO speed of Polaroid film, *not* compensated value.

For example, compensated ISO for this photograph was 200; true ISO of Polachrome film is 40. To get equivalent exposure with conventional film that has ISO of 100, exposure must be decreased by 1⅓ stops.

Specimen courtesy Carolina Biological Supply Co. Inc.

Off the film ambient light meters

A few 35mm cameras use off the film metering systems to control *ambient light* exposures when shutter speeds are longer than ⅟₆₀ second. These cameras include the Olympus OM-2, OM-2N, OM-4, OM-10, OM10-FC, OM-10 Quartz, OM-F, OM-G; Pentax LX; and Minolta CLE. (Other cam-eras may have this metering system; check their instruction manual.) Like off the film *flash-metering* systems, these cameras read the light reflected off the film, but in this case, during long exposures. Here, too, Polaroid 35mm films reflect less light than the amount to which off the film meters are calibrated.

When these cameras are used in their *automatic* aperture prior-ity mode, check the viewfinder readout to see if the correspond-ing shutter speed is slower than ⅟₆₀ second. (The ISO dial should be set to the true film speed.) If a shutter speed slower than ⅟₆₀ second is indicated, do not use the automatic mode. Instead, set the aperture and shutter speed *manually* as indicated by the meter in the viewfinder.

Polaroid 35mm instant films expedite alignment, exposure, and visualization tests required for multiple-exposure title slides. Here a stock grid-graphics slide was copied on Polachrome film. A second exposure on the same frame through a yellow filter burned in the word "Polaroid". This white-on-black lettering came from a Polagraph slide made using reverse text procedure explained on page 83.

Courtesy Visual Horizons, Inc.

Polagraph slide Polachrome copy of grid slide

Polachrome slides

Duplicates of Polachrome slides can be made by any processing service that handles conventional slides. Alternatively, with standard slide-copying equipment, you can duplicate Polachrome originals in the same manner as conventional transparencies. However, due to its higher base density, the duplication of a Polachrome original requires about 1⅔ stops more exposure (or the equivalent in longer exposure times or brighter illumination) than conventional originals. In addition, the filter pack for duplicating an average Polachrome slide typically requires about CC15-30 more green or cyan, depending on duplicating film, than a pack for the same scene exposed on conventional film.

The best films for duplicating Polachrome originals are the same special, low-contrast duplicating emulsions used for high-quality duplication of conventional films. Kodak Ektachrome Slide Duplicating Film 5071 is best suited to a tungsten duplicating light source; Ektachrome SE Duplicating Film SO-366 is appropriate for electronic flash sources.

Duplicate slides of Polachrome originals, made on the films just noted, will have color and contrast very similar to the originals and a base density of conventional films.

Although Polachrome originals are best duplicated on special films mentioned above, a general purpose film such as Kodachrome 25 (*right*) can be used if increased contrast is acceptable.

Moiré lines usually result when Polachrome film is used to duplicate Polachrome originals (*far right*). Duplicating lens apertures of f/22 or f/32 will eliminate moiré, although there may be a small loss of sharpness in very fine details due to lens diffraction.

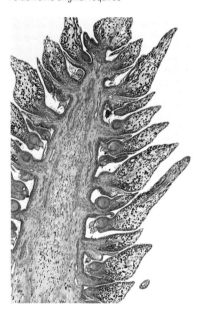

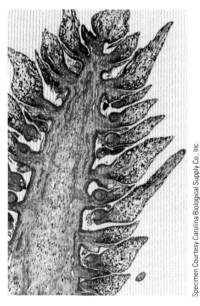

Specimen Courtesy Carolina Biological Supply Co., Inc.

Polaroid Copy Service
Copy slides, prints, and enlargements from Polachrome, Polapan, and Polagraph slides are available from the Polaroid Copy Service. For additional information, call toll free (800) 421-1030 in the continental U.S.; in California, call collect (213) 643-8093.

Ektachrome 5071 film is recommended for best quality duplicates of Polachrome originals. Kodachrome 25 film can also be used if increased contrast is desired. Colors in duplicate will not perfectly match colors in original because Polachrome and conventional film dyes are different. Filter pack for duplicating Polachrome slides on Ektachrome film is approximately CC20C more (or CC20R less) than pack used for duplicating conventional films.

When using Polachrome film to make duplicates of conventional, continuous tone color slides, flashed duplicates (technique explained on page 41) will have better shadow detail than unflashed duplicates. However, for graphic and low contrast originals, increased contrast of unflashed duplicates is often beneficial.

Original Polachrome slide

Duplicate on Kodachrome 25 film

Duplicate on Ektachrome 5071 film

Original Kodachrome slide

Duplicate on Polachrome film

Flashed duplicate on Polachrome film

Polapan and Polagraph slides

Polapan and Polagraph slides can be duplicated by any commercial facility offering slide duplicating services. Duplicate slides and prints from slides can also be ordered from the Polaroid Copy Service (see page 81).

If you duplicate your own Polapan slides, excellent copies can be made using special low-contrast, color duplicating emulsions such as Ektachrome Slide Duplicating Film Type 5071 or Type SO-366 (see page 81). Because the base density of Polapan film equals that of conventional color slide films, duplicating exposure times are similar to those used for conventional color slides.

Polapan film can be used to duplicate Polapan slides, particularly when the need for fast results outweighs the need for closely matched tone reproduction. These duplicates will show more contrast than the originals and will lose detail in dark-toned areas. The shadow detail can be noticeably improved by *flashing,* which is exposing the duplicating film to a low level of uniform light after the main exposure is taken (see example below).

Polagraph film yields excellent duplicates of Polagraph slides and requires no special techniques.

Original Polapan slide

Polapan duplicate of Polapan original. Note loss of detail in both shadows and highlights, and overall increase in contrast.

Flashed duplicate shows contrast and tonal detail much closer to original than unflashed duplicate. Flash exposure was made through a 2.0 neutral density filter; lens was opened 1 stop more than for main exposure. While this is typical value for most flash exposures, tests are necessary to determine exact amount of flashing for your equipment and slides.

Polapan slide (*above*) can be rendered more graphic by copying original on Polagraph film.

Duplicate slide on Polagraph film has eliminated many light and dark grays, leaving mostly white, black, and a few medium tones. Bracket exposures in increments of 1/3 or 1/4 stops; results vary radically with small differences in Polagraph exposure.

Duplicating slide at left again on Polagraph film further increases contrast and emphasizes grain. As before, exposure is extremely critical.

Title slides

Polaroid 35mm instant films can be used to easily make title slides. Reverse text slides (white or colored letters and lines on a black background) are particularly useful because of their bold contrast and excellent visibility, even under adverse projection conditions. The example below demonstrates one method of producing colored, reverse text slides, without a darkroom and using only Polaroid instant films.

First, photograph the original artwork (black letters on a white background) on Polagraph film (*far left*). Next, use a large-format camera or a desk-top slide printer (see pages 86-90) to copy that Polagraph slide onto Polaroid Type 55 or Type 665 film, materials that produce a usable print in addition to the negative (*second from left*). (If the original artwork is clean and contrasty and a large-format camera is available, photograph it directly onto Type 55 or Type 665 film, bypassing the first step.)

Place the negative on a light box and photograph it with Polagraph film; this returns the format to 35mm and ensures a dense black background (*second from right*). The Polagraph slide can be projected as is, white on black, or gels can be taped to it to create overall or specific areas of color (*far right*). To prevent the gels from jamming in a projector, mount the slide in glass, or copy it on Polachrome or conventional film.

Polagraph slide of original artwork

Polaroid Type 665 negative made from Polagraph slide at left

Polagraph slide of Type 665 negative

Colored gels taped behind Polagraph slide at left

Polaroid 35mm instant films are very effective for the quick editing and printing needs of newspaper publishers, particularly those with small photography staffs. Such newspapers are generally not equipped to reproduce black-and-white slides, so Polapan or Polagraph originals must be converted to prints.

The accident scene above was photographed on Polapan film. At the newspaper's office, the film was processed and edited in 5 minutes. Ten minutes later the print required for reproduction was ready; it was made using a stabilization processor and the paper negative technique described on page 94. If a desktop printer or an MP-4 camera had been available, a print could have been made in 2 minutes without a darkroom.

Printing methods

Polaroid 35mm slides can easily be converted into color or black-and-white prints using the same printing techniques used for conventional transparency materials. All professional photographic services and consumer photofinishing outlets can make prints from Polaroid 35mm slides. A wide variety of prints also can be obtained from the Polaroid Copy Service (see page 81).

Polaroid 35mm slides can be made into prints, up to 8 x 10 in. (18 x 24 cm), quickly and without a darkroom, using Polaroid instant films. Slides can also be converted into overhead transparencies. Desk-top instant slide printers offer the most convenience, but they have limited controls for cropping and color manipulation. You can greatly increase cropping and color control by using a copystand camera or darkroom enlarger.

When the highest quality prints are desired, print the slides on conventional darkroom papers. These include both direct reversal and negative-working papers (an internegative is required for the latter). If a darkroom is available, you can produce such enlargements yourself, or else send it to a commercial lab.

▷
The same materials you use to make prints of conventional color slides can be used with equal success to print Polachrome slides. Here, Agfachrome-Speed paper was used for enlargement of computer graphic originally photographed on Polachrome film. Black borders always occur when slides are printed on direct reversal papers.

Courtesy Brilliant Image, Inc.

Instant slide printers

A variety of desk-top units are available for making instant prints from 35mm slides. All have built-in electronic flash, controls for lightening and darkening the prints, and a slot for gelatin color-balancing filters. The more sophisticated units can print either the full slide or a slightly cropped version; others print only the full frame or only a slightly cropped image.

All printers, except for the Polaroid Polaprinter 8 x 10 slide printer, accept Polaroid 3¼ x 4¼ in. pack film: Type 669 for color prints and Type 665 for the simultaneous production of a black-and-white print and negative. The negative can be used to make high-quality conventional black-and-white enlargements. The versatile O+ER Proprinter II made by Optical and Electronic Research, Inc., accepts all Polaroid pack films as well as all Polaroid and conventional 4 x 5 in. (9 x 12 cm) sheet films.

The Polaroid Polaprinter 8 x 10 slide printer operates in conjunction with the Polaroid 8 x 10 film processor. Together they produce instant 8 x 10 in. (18 x 24 cm) color prints or overhead transparencies from color slides. The system works equally well with black-and-white slides (see page 89).

Large-format Polaprinter (*right*) exposes slides on Polaroid 8 x 10 in. instant film or on conventional film and paper. O+ER Proprinter II (*center*) has interchangeable backs for exposing any instant print or conventional film, adjustable lens diaphragm, and three cropping settings. Vivitar Instant Slide Printer (*far right*) has automatic exposure control and accepts Polaroid print materials in 3¼ x 4¼ in. format. Other small printers are made by Polaroid and Samigon.

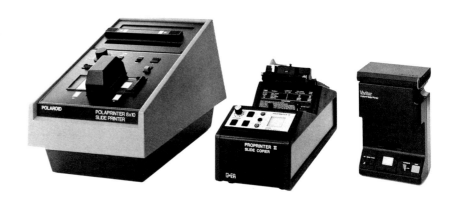

Polaroid instant films for making prints from slides

Listed below are Polaroid materials for making instant prints from slides. Select the appropriate size for your printer. For occasional needs, Polapan and Polagraph slides can be printed on color print materials, however, results are usually more pleasing when black-and-white films are used.

Film Type	Results	Format	Comments
665	Black and white print and negative	3¼ x 4¼ pack	Use negative to make high-quality enlargements on conventional paper.
55	Black and white print and negative	4 x 5 sheet	See above.
52 552	Black and white print	4 x 5 sheet 4 x 5 pack	Use instead of Type 55 if only a print is required.
51	High contrast black and white print	4 x 5 sheet	Use for Polagraph slides, or for making high-contrast graphic prints of Polachrome or Polapan slides.
611	Black and white print	3¼ x 4¼ pack	Has low contrast. May be used for printing Polapan slides of contrasty subject. Not for use in printers that have only automatic exposure control.
669 (668*)	Color print	3¼ x 4¼ pack	For all color slides. Also produces very satisfactory results with Polapan and Polagraph.
59 559 (58*)	Color print	4 x 5 sheet 4 x 5 pack	See directly above.
809 (808*)	Color print	8 x 10 sheet	See directly above.
891	Color overhead transparency	8 x 10 sheet	See directly above.

*This film, which has higher contrast, may be preferred for some subjects.

Instant prints from Polachrome slides

Polachrome slides can be printed on any of the instant color films listed in the table on page 86. For best results, filtration is required in the slide printer. With printers using flash illumination, Polachrome slides usually require about CC20G + CC30C more filtration (or CC20M + CC30R less filtration) than is used for printing Kodachrome slides on Types 669, 59, and 559 film. Compared to Ektachrome slides, the filter pack is about CC30G more or CC30M less. If you are making prints of Polachrome slides on conventional film and no filtration recommendations have been established, begin your test exposures without filtration. In printers with manual exposure control, Polachrome slides may require more than one flash "pop."

Filters can be used to correct or to deliberately alter the color balance of the original slide. In the example below, the Polachrome slide, exposed in shade, had a strong blue-magenta cast. Printed with a standard filter pack, the print, made on Type 669 film, matched the original fairly well (*left print*). When CC20G + CC40Y filters were added, the color cast was removed completely (*right print*).

Allow Polaroid instant color prints to dry for several minutes before evaluating the color balance. The prints have a slight color cast when first separated from the negative.

Polachrome slide

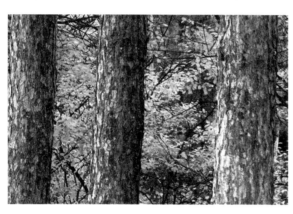

Print made with standard filter pack

Print made with CC20G + CC40Y added to standard filter pack

Instant prints from Polapan slides

Polapan slides can be printed on any of the instant black-and-white materials listed in the table on page 86. In 4 x 5 in. size, Type 52 (or 552) film is recommended over Type 55 film if a negative is not required.

Type 665 film must be used for 3¼ x 4¼ in. black-and-white prints in slide printers that have automatic exposure control. The negative produced with the print can be discarded if it is not needed for making enlargements (see page 88).

If your printer has total exposure control, Type 611 pack film can be used, particularly if the original slide is contrasty or has a long brightness range. Type 611 film is designed for video image recording, but, as the example below shows, it also produces excellent prints from Polapan slides. If the original slide is lacking in contrast, Type 665 film is a better choice.

Black-and-white Polapan slides can also be printed quite satisfactorily on Polaroid color print films. A fairly neutral image may require filtration; use a CC25M + CC10B filter pack as a starting point with flash illumination. Other filtration can be used to produce prints with a sepia or other color tint (see example on page 89).

Polapan slide

Print made on Type 665 film

Print made on Type 611 film

Instant prints from Polagraph slides

Polaroid Type 51 high-contrast film is ideal for making instant 4 x 5 in. prints from Polagraph slides. Type 51 prints have very clean whites and very dense blacks. With slide printers that accept only 3¼ x 4¼ in. pack film, print Polagraph slides on Type 665 film, or Polacolor Type 668 film with filters to adjust background color if desired.

▲
Polagraph slide

▶
Print made on Type 51 film
(cropped section of slide)

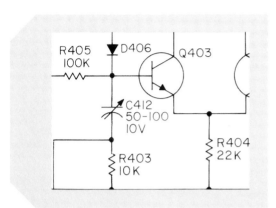

Instant negatives for darkroom prints

When more printing flexibility is required than is possible with a simple black and white print, Type 55 (and its pack film equivalent, Type 665) are recommended. These films produce both an instant print and a fine-grain negative, which can then be enlarged and altered in the darkroom using traditional printing controls.

▼
Polapan slide

▼
Type 55 negative

◀
This is correctly exposed Type 55 print. For best negative, overexpose print by ½ to 1 stop.

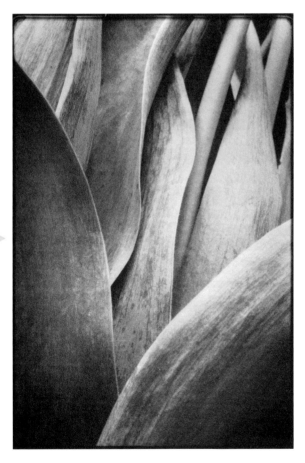

▲
A negative gives you darkroom control over such things as image magnification, contrast and density (local and overall), and final print size.

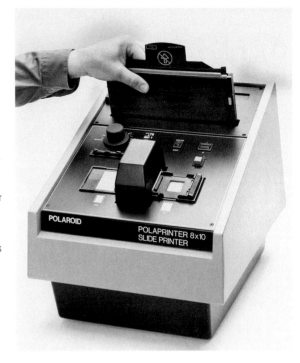

Instant overhead transparencies

With the Polaroid Polaprinter 8 x 10 slide printer (*right*) and Polaroid Colorgraph Type 891 film, you can make instant 8 x 10 in. (18 x 24 cm) overhead transparencies of Polaroid 35mm slides.

The Polaroid instant slide is first exposed on Type 891 film in the Polaprinter 8 x 10 slide printer or under an enlarger (see page 91). The film is then developed in room light in the Polaroid 8 x 10 film processor. The entire process takes about 15 minutes, which is very convenient when an overhead transparency is needed quickly for a presentation.

Courtesy Brilliant Image, Inc.

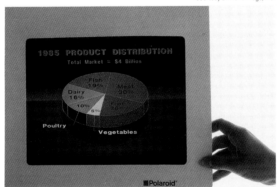

All Polaroid 35mm slides can be converted to Colorgraph overhead transparencies. Best results are obtained from contrasty, graphic images, such as this Polachrome slide of a computer graphic (*far left*). (Conventional slides can also be enlarged on Colorgraph film.) For easier handling, overhead transparencies can be mounted in Polaroid Colorgraph projection mounts (*left*).

Instant 8 x 10 prints

The Polaprinter 8 x 10 slide printer can also expose Polachome slides for instant 8 x 10 prints on Polacolor ER Type 809 instant film. Alternatively, the film can be exposed in a Kenro 8 x 10 head that fits the Polaroid MP-4 camera system (see next page).

Polapan and Polagraph films can also be printed on Type 809 film. In this example the Polapan slide (*below*) was printed on Type 809 film using yellow and magenta filtration to produce a warm-tone image (*right*).

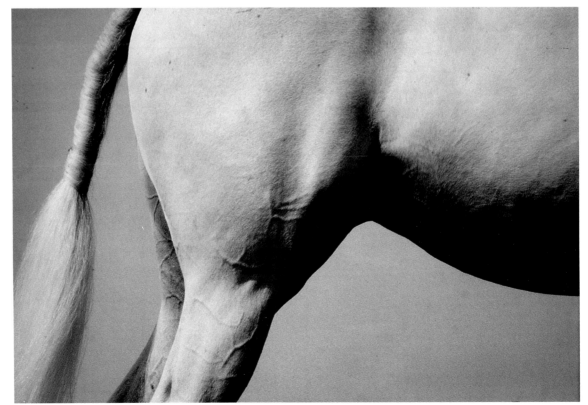

Instant prints with an MP-4 system

The combination of a slide-duplicating illuminator and a Polaroid MP-4 camera system is a more versatile alternative to a desk-top slide printer. With the MP-4, adjustable bellows and unrestrained slide positioning permit any desired cropping. The MP-4 head accepts film holders for most Polaroid film types and for all sizes and types of conventional film up to 4 x 5 in. (9 x 12 cm). A camera head for Polaroid 8 x 10 film is available from Kenro Corporation and other manufacturers.

The slide-duplicating illuminator's dichroic color filters permit convenient broad-range color correction.

The illumination section of most slide duplicators can be placed on the baseboard of an MP-4 by detaching the duplicator's 35mm camera support. Shown here is a slide duplicator from the Kenro Corporation; similar units are made by Beseler, Double M Industries, Leedal, and Oxberry.

To print a Polaroid slide, use an MP-4 50mm lens to cover 3¼ x 4¼ in. and 4 x 5 in. print materials. Lower bellows to almost maximum extension, then focus on slide by carefully raising and lowering head.

Series of test exposures on one sheet of Type 59 film was made using technique described at right. With Polaroid pack films, incremental exposures can be made by withdrawing darkslide of pack film holder in small steps. Evaluate color prints under lighting conditions to be used for final viewing.

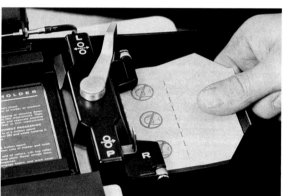

Cropping flexibility of this printing system permitted convenient enlargement of a specific section of slide. To ensure sharpness, use an aperture of f/8 or f/11; be careful to eliminate all sources of vibration, and use a level to adjust slide holder accurately, parallel to lens rim, both front-to-back and left-to-right.

Polaroid 4 x 5 sheet films have an outer envelope that can be used to produce exposure series on one sheet of film. After withdrawing envelope and checking pod area, make first exposure and push envelope in about 1 in. (25 mm). Continue making exposures and pushing in envelope until series is complete. Remember that each exposure is added to preceding ones.

Darkroom enlargements

Instant darkroom prints

Producing instant prints with an enlarger is a relatively inexpensive alternative for those who have a darkroom but not a slide duplicator or a large-format, vertical copy camera.

Optical and Electronic Research, Inc. (O+ER) makes a series of enlarging easels that hold Polaroid film beneath a darkroom enlarger. A slide is inserted in the enlarger and projected onto the surface of the appropriate sheet or pack film; various holders accommodate 8 x 10, 4 x 5, and 3¼ x 4¼ formats (*below*). Sizing, cropping, and color correction controls are similar to those possible with the MP-4 system. The O+ER system also permits dodging and burning in of specific image areas.

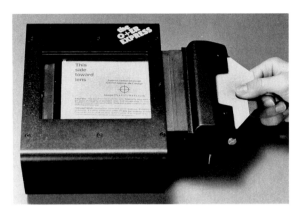

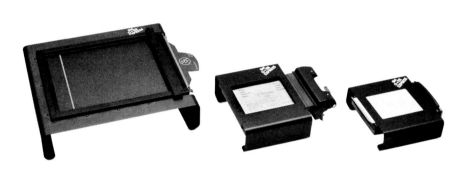

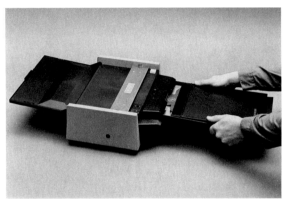

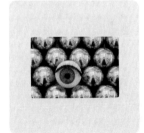

Original Polachrome slide (*above*) was enlarged in darkroom onto Polacolor 8 x 10 Type 809 film (*right*). Basic exposure with diffusion enlarger under tungsten light was 21 sec. at f/16 (using 20Y + 10C filter pack). Perimeter of print was moderately dodged. Eye received additional 85 sec. exposure through 70C + 70M (= 70B) filtration. Cropping versatility and speed of processing recommend this procedure for proofs, composites, and layouts. Polapan and Polagraph slides can also be printed on Polacolor Type 809 film (see page 89).

O+ER's 4 x 5 easel (*top*) holds a Polaroid model 545 sheet film holder in position beneath enlarger. Polacolor 8 x 10 prints or Colorgraph Type 891 overhead transparencies are exposed in a Polaroid 8 x 10 holder, which fits the O+ER model 810 easel. After exposure, they are developed in room light in a Polaroid 8 x 10 film processor (*bottom*). No safelights should be used while exposing any Polaroid materials.

Prints from direct reversal materials

Although instant prints offer speed and convenience, the highest quality enlargements are produced in the darkroom on wet-processed materials. Wet-processed papers offer excellent color fidelity; contrast specifically matched to the brightness range of transparencies; extensive opportunity for dodging, burning in, and masking manipulation; and unlimited size and cropping possibilities.

All Polaroid 35mm slides can be printed using the negative-positive process (see pages 94-96) or with direct reversal materials. Direct reversal produces a print directly from the slide without an internegative. These materials work best with low to medium contrast slides; contrasty originals may require extensive dodging and/or burning in. Polaroid 35mm films print well on all common reversal papers that use multi-step chemical development such as Cibachrome and Ektachrome 22. Results are

also very good on Agfachrome Speed and Ektaflex, which are one-step, rapid processing materials suitable for darkrooms lacking critical chemistry temperature controls.

Because direct reversal, continuous tone, black-and-white papers are not readily available, Polapan slides can be printed on the color materials noted above. With proper filtration, color balance can be adjusted for neutral grays or for hues imparting the

look of a chemically toned, conventional black-and-white print.

Diffusion enlargers are generally recommended for printing color because they eliminate many of the spots caused by dust. Condenser enlargers are also suitable. Insert Polaroid 35mm slides into the enlarger with the silvery emulsion side facing up. Remove dust with compressed air or a camel's hair brush *only*; the relatively soft emulsion is easily scratched.

The base density of Polachrome film requires exposures that are typically 1½ to 2 stops more (or the equivalent in longer exposure time) than exposures for conventional film. The filtration for printing Polachrome is approximately CC30M less (or CC30G more) than the filtration required for printing an Ektachrome slide of the identical scene. The printing exposure for Polapan is similar to that for conventional film. Underexposed slides will increase printing time.

Cibachrome-A II print (*far right*) from Polachrome slide (*right*) required 14 sec. exposure at f/8 for a 6 x 9 in. (15 x 23 cm) enlargement. Filter pack for tungsten diffusion enlarger was CC30M less than pack used to print Ektachrome slide of identical scene. (For comparison, see same slide printed from an internegative on page 96.)

Polapan slides (*right*) can be successfully printed on enlarging paper intended for color slides. For completely neutral color rendition, suggested starting filter pack is approximately CC15M + CC10Y *added* to paper manufacturer's recommendation for printing Ektachrome slides. An additional CC20B was added here to impart cool tone to ice formation (*far right*).

Prints of Polagraph slides

Polagraph slides can be enlarged directly on the color reversal materials recommended for Polachrome. By adjusting the filter pack, white areas can be rendered neutral or tinted with color.

Alternatively, a negative-positive process can be used, such as the paper negative technique shown on page 94. Polagraph slides can also be copied to produce a negative, either on Polaroid Type 55 or Type 665 instant film or on conventional film; that negative then yields a conventional black-and-white print.

Diffusion-transfer materials are particularly convenient for enlarging Polagraph slides of line art and similar graphic subjects. These high-contrast graphic arts products, such as Agfa Copyproof and Kodak PMT, are one-step papers and films that produce both direct positives and direct negatives on film or paper. They are developed in desk-top, diffusion-transfer processors. The processors use only one chemical and require no critical temperature control. In this example, a section of a Polagraph slide (*left*) has been exposed onto Agfa Copyproof negative CPN paper and transferred to positive CPG paper (*right*).

Polagraph slide

Courtesy Radio Shack

Diffusion transfer print

Chromatic aberration patterns

When Polachrome slides are made directly into 5 x 7 in. (13 x 18 cm) prints or larger, there may be a curved streak or colored band through the print. This pattern, which may be mistaken for a processing chemical stain, is caused by the optical interaction of the color filter stripes in the base of Polachrome film and the chromatic design of the enlarger lens. (This pattern does not occur in prints made from Polapan and Polagraph slides because they do not have the color filter stripes in their film base.) These patterns are usually noticeable only in large, even-toned, very light areas, such as an almost white sky or a white building that predominates in the scene.

The visibility of the pattern is related to the scene photographed, and on the enlarger alignment, the amount of chromatic aberration in the enlarger lens, and on the enlarger lens aperture.

A properly aligned enlarger and a glass negative carrier to keep the Polachrome slide flat may lessen the visibility of the pattern. The pattern may usually be eliminated completely by using a small enlarging lens aperture. For example, at f/4 the pattern is usually most noticeable. Closing down to f/8 markedly decreases the colored bands. By f/11 the pattern will be unnoticeable in most pictures; f/16 may be required in stubborn cases.

Prints made from 4 x 5 in. (9 x 12 cm) or smaller internegatives of Polachrome slides do *not* exhibit the pattern, nor do prints made in desk-top instant printers.

Salmon-colored bands (*right*) occurred when Polachrome slide, which had large white area, was enlarged onto direct reversal paper using an enlarger lens aperture of f/4. Closing lens to f/11 eliminated the pattern (*far right*).

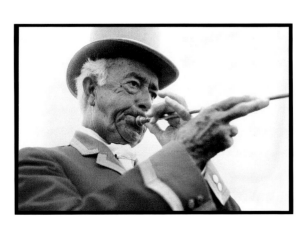

Prints from paper negatives

An alternative to printing Polapan and Polagraph slides on color reversal materials is to photograph the slide on negative film and use the resulting internegative to make prints on conventional black-and-white paper. A variation on the film negative is the paper negative, which makes it possible to make prints from slides using only an enlarger, a contact printing frame, and standard black-and-white printing materials.

Polapan and Polagraph slides produce negative prints when enlarged on conventional black-and-white paper. (These negative prints are themselves sometimes useful.) When dry, the paper negative is placed in tight contact with a second, unexposed sheet of enlarging paper, and the pair is exposed to white light under the enlarger. Development of the second sheet of paper produces a positive print.

The advantage of this paper internegative technique is that no special photographic equipment or special internegative film is required. Using resin-coated or stabilization paper, finished prints can be ready within 30 minutes. However, a separate paper negative is required for each different print size, and image sharpness is not as high as in prints from good film internegatives.

To make a paper negative, first insert Polapan slide (*right*) into enlarger with emulsion side down. Project slide onto enlarging paper in same size as the desired final print. (Single weight paper used for negative produces slightly sharper final prints than medium or double weight paper.) Since contrast range of slides is generally much greater than contrast range of paper, start with grade #1 paper (or the equivalent variable contrast material). Then, dodge and burn in as required so that all important details visible in slide clearly show on paper negative (*far right*). Dodging and burning in are very important and generally more extensive than when printing from negatives.

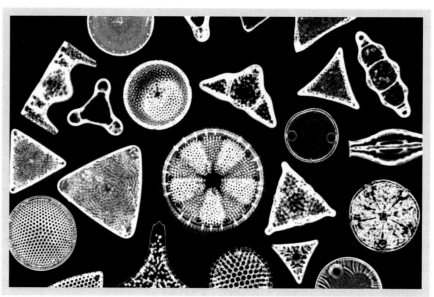

When paper negative is dry, place it in contact printing frame, emulsion to emulsion, with an unexposed sheet of enlarging paper (back side of paper negative in contact with the glass). Set enlarger to project rectangle of light through empty negative carrier; rectangle should be somewhat larger than print frame. Use lens aperture of around f/5.6. Light passing through paper negative exposes enlarging paper, producing a positive image. Print will have a black border. Contrast of print can be controlled by grade number of enlarging paper or variable contrast filter.

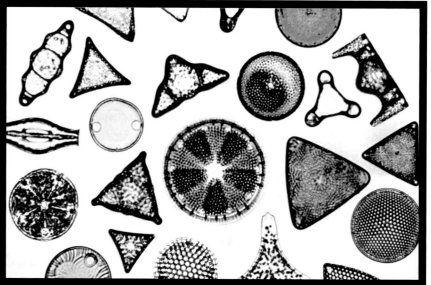

Specimen courtesy Carolina Biological Supply Co., Inc.

Polagraph film and paper negative printing technique provide convenient way to produce reverse (white-on-black) text or graphics. Original artwork (black-on-white) is copied on Polagraph film, producing a positive image. When enlarged onto paper intended for printing from negatives, that positive creates a negative-looking print. (If color negative paper is used, background color can be altered by adjusting filter pack.) Photographing the negative print on Polaroid or 35mm transparency film creates bold, graphic slides.

Polagraph slide

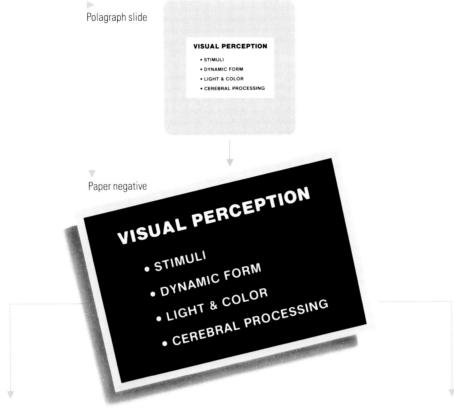

Paper negative

VISUAL PERCEPTION

- STIMULI
- DYNAMIC FORM
- LIGHT & COLOR
- CEREBRAL PROCESSING

Polachrome slide was produced by photographing paper negative through Wratten #47B blue filter. Color saturation in letters is determined by exposure.

Increasing exposure through Wratten #47 filter produces blue background with white letters.

VISUAL PERCEPTION

- STIMULI
- DYNAMIC FORM
- LIGHT & COLOR
- CEREBRAL PROCESSING

To make title slides with white letters on pictorial background, camera that can make double exposures is required. Here, first exposure on Polachrome was for background art.

Second exposure on same frame was photograph of white-on-black paper negative shown above. Use an 18% gray card to determine exposures; set camera on "Manual."

VISUAL PERCEPTION

- STIMULI
- DYNAMIC FORM
- LIGHT & COLOR
- CEREBRAL PROCESSING

Prints from internegatives

Enlargements made from inter-negatives of original slides generally permit better contrast control than do reversal prints made directly from the slides. When the original is contrasty, a print from the internegative is usually preferable.

If you do your own color print-ing, color internegatives can be ordered from almost any photo-finishing service. For most pur-poses, inexpensive 2¼ x 3 ¼ in. (6 x 9 cm) machine-made internegatives are satisfactory. Handmade 4 x 5 in. (9 x 12 cm) internegatives should be used when the best possible quality is required. Black-and-white inter-negatives of Polapan and Pola-graph slides can also be obtained from a photofinishing service, or they can be made using a slide duplicator and a fine grain film, such as Kodak Technical Pan 2415 developed to a low contrast, or by using a slide printer and Pola-roid Type 55 or Type 665 positive-negative film (see page 88).

Polachrome slide

Internegative

Ektacolor 74 print

Masking to control print contrast

Enlarging paper for printing black-and-white negatives is available in various contrast grades. If the negative is too contrasty, it can be printed on low-contrast paper; if it lacks contrast, high-contrast paper can be used. Unfortunately, such con-trast control is unavailable in most reversal papers intended for directly printing slides, or in papers used to print color nega-tives and internegatives.

When contrasty or flat lighting produces excessively contrasty or flat Polaroid slides, enlarged prints from such slides can be improved by standard dodging and burning-in. However, the most versatile, precise, and flexi-ble contrast control is provided by a technique called *masking,* which can either increase or decrease print contrast.

Masking to *decrease* contrast consists of making a black-and-white, low-density, low-contrast sheet film negative, or mask, of the original slide. For printing, the mask is sandwiched with the slide. Because the mask is dense where the slide is almost clear, the density range of the slide-plus-mask is lower than the slide alone. Since the density range is decreased, particularly in the highlights and light tones because the negative mask is given a weak exposure, overall contrast is reduced. However, lowering the contrast can create flat highlight areas that lack detail. To correct this, a negative highlight mask can also be made, using a high-contrast lithographic film. Masking to *increase* con-trast uses similar procedures, except positive, black-and-white masks are required.

You can make masks in any darkroom if you can process black-and-white sheet film. Alter-natively, many professional pro-cessing labs will make individual masks and prints from masked slides.

This Polapan slide (*right*) has extreme contrast, with detail in both the deep black areas of the coat and the stark white area of the shirt. When a straight print was made (*bottom left*), highlight detail was lost.

To obtain a better print, a contrast-reducing mask was made. The original Polapan slide was placed, emulsion side up, on a piece of Kodak Diffusion Sheet. Below the diffusion sheet was a piece of Kodak Pan Masking Film 4570, emulsion up, followed by a piece of black paper to prevent reflection. Glass on top pressed the layers into even contact.

The diffusion material between the slide and masking film creates a slightly out-of-focus, "soft edge" mask. This permits relatively easy alignment of the developed mask and the slide; no pin registration system is required.

The masking film produced a negative (*center*) that has weak to moderate density in the areas that correspond to light tones in the slide, and no density at all where the slide has medium and dark tones. After this mask was processed and dried, the slide was carefully aligned on top of the mask (*far right*) and taped into position.

 Polapan slide Mask Slide plus mask

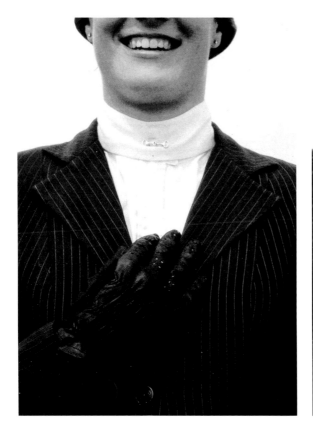

The straight print (*right*) from the contrasty Polapan slide above shows a characteristic loss of detail in very light tones, most noticeable in the shirt and chin. The print (*far right*), made from the same slide sandwiched with the contrast-reducing mask, has identical dark and middle tones, but more detail in the light tones. Masking works equally well when making prints from Polachrome slides.

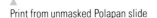 Print from unmasked Polapan slide Print from masked Polapan slide

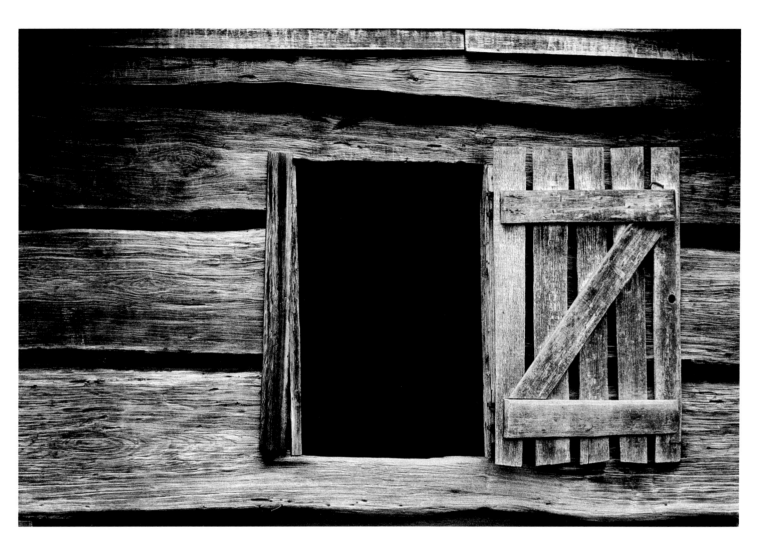

Large image shows Polapan slide that has been treated in Berg Gold Protective Solution; smaller photograph shows appearance of untreated film. Shift in tone from "warm" to "cool" also occurs with Polachrome slides. Gold toning is recommended when developed Polaroid 35mm films will be stored for long periods in warm, humid climates.

Storing unexposed film and processing pack

Store unexposed Polaroid 35mm film and the unused processing pack in the original box. Do not remove the film cartridge from its plastic canister until you are ready to use it.

For short-term storage (8 to 16 weeks) the film and processing pack may be kept at room temperature (70°-80°F/21°-27°C). For longer periods, store below 70°F (21°C). Refrigerated storage is recommended, but do not freeze it. To avoid condensation, remove the film from the refrigerator and allow it to warm up for at least one hour before opening the canister.

In warm climates where air conditioning and refrigeration are unavailable, keep the unopened film boxes in as cool and shaded an environment as possible. Do not leave the film, processing pack, or loaded camera in a car or truck in warm weather, or in direct sunlight.

Of the processing pack and film, it is the processing pack that is more prone to deterioration caused by improper storage. Thus, when photographing in hot climates, leave the processing pack in a cooler environment and carry only the film.

Storing exposed film

Polaroid 35mm films have latent image-keeping properties similar to those of conventional films, but it is best to process the film as soon after exposure as possible. If the exposed film cannot be processed immediately, put the film into its canister and protect it from high temperatures.

Storing processed slides

Unmounted strips of Polaroid 35mm film can be kept in sleeves made of acid-free paper, cellulose acetate, polyethylene or polyester. Mounted slides can be kept in metal cabinets, or in boxes or storage pages made of one of the materials recommended for sleeves. Slide trays, placed inside their original closed boxes, also make good storage containers.

Storage containers should be kept in a cool, dry place, ideally at 50°-70°F (10°-21°C) and 30%-50% relative humidity.

Elevated temperatures and high relative humidity will accelerate image fading.

Protect the processed film from chemical contaminants such as vapors from solvents, paints, exhausts, and air pollutants. Also do not let the film come in contact with non-acid-free paper; plastics (such as PVC) that contain volatile plasticizers; and painted surfaces, wood, glue and other materials containing chemicals harmful to silver images.

Toning for additional protection

If the slides are stored in areas that may be subject to extreme heat and/or humidity, or to atmospheric pollution, they may be treated with a commercially available gold toning solution for additional protection. The gold toning treatment changes the warm tones of Polapan film to more neutral or slightly cool tones. Similarly, the color balance of Polachrome film is also shifted toward the blue end of the spectrum. For the specific method of treating Polaroid 35mm films, contact Polaroid Technical Assistance (see page 5).

When very important slides must be stored for many years without any image change, Polapan and Polagraph films can be copied onto conventional films that are archivally processed and stored. Similarly, Polachrome slides can be converted to sets of black-and-white color separation negatives, and each of the three negatives archivally processed and stored.

High heat and humidity adversely affect image stability of processed film. Control slide (*right*) was stored for one year at 68°-74°F (20°-23°C) and 40%-50% relative humidity. An identically exposed slide (*far right*) was also stored for one year, but in tropical environment with average temperature of 80°F (28°C) and average relative humidity about 75%.

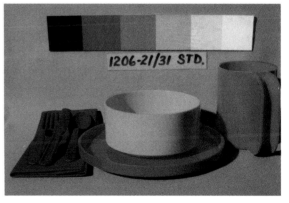

Polaroid 35mm instant films are widely used in the production of visuals for educational purposes, such as slides for art classes. This Polachrome slide of Fra Filippo Lippi's painting *Madonna and Child* was copied from a book.

Courtesy National Gallery of Art

Photographing drawings and illustrations

Many slides used for instruction, education, and presentation are photocopies of drawings, typewritten copy, pictures, and illustrations from manuals, reports, and books. Polaroid 35mm films are well suited for reproducing such color, black-and-white, and line images.

The almost universal availability of 35mm single-lens-reflex cameras with through-the-lens metering makes photocopying a relatively straightforward task, even for the inexperienced photographer. Other than a cable release, a bubble level, and an 18% gray card, all that is required for photocopying is a vertical copystand and two photographic lights. Many relatively inexpensive copystands, complete with lights, are serviceable for originals up to about 9 x 12 in. (23 x 30 cm). Larger, heavy duty copy systems are recommended for frequent work or large originals. Although a macro lens is best for critical or frequent photocopying of flat art, a common macro-zoom lens or even a normal 50mm optic usually produces acceptable results when used properly.

Photocopy setup consists of baseboard, camera support column, sliding camera carriage, and lights placed at 45° on both sides. Illumination on baseboard must be uniform; uniformity is controlled by distance of lights.

One light on each side of column is adequate; two lights on each side produce the same uniformity but at a shorter distance. Shown is Polaroid MP-4 system and universal camera mount.

Any 35mm SLR camera that permits manual setting of lens aperture and shutter speed can be used. Trip shutter with cable release to prevent vibration.

Place copystand on sturdy table in an area free of strong vibrations. Eliminate or block off any ceiling and window light.

Bolt column at a right angle to baseboard so that camera is parallel to baseboard in front-to-back direction. Camera must also be parallel to baseboard in left-to-right direction. To do that, place bubble level as shown and insert temporary shims under baseboard until it is level.

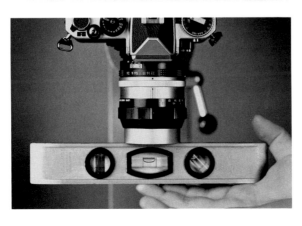

Press level against lens rim and pivot camera to center bubble in level. After camera-holding screw is tightened, check camera alignment again with level. Screw must be snug to prevent camera from pivoting when film advance lever is operated.

Remove temporary shims under baseboard. Camera is now parallel to baseboard, which helps ensure edge-to-edge image sharpness and minimal distortion.

Lens for general purpose photo-copying should have 50–55mm focal length. Macro lenses offer most convenience and best sharpness and contrast. Zoom lenses with close-up capabilities are satisfactory if their close-up focal length is around 50mm and if apertures of f/11 or f/16 are used. Normal 50mm camera lenses will focus in the close-up range when inexpensive, supplementary close-up lenses are attached (*left*). Quality will be reasonably good if apertures are restricted to f/8 to f/16. In fact, due to very shallow depth of field in the close-up range found in photocopying, all lenses should be used at moderate to small apertures.

Tungsten lights (*left in photo*) can be used with all films, but Polachrome film requires appropriate daylight-to-tungsten conversion filter on camera lens (see page 29). When Polapan and Polachrome are used with tungsten copystand lights, exposure times will usually be long enough to require correction for reciprocity failure (see pages 66-69). Substituting electronic flash for tungsten lights eliminates heat, reciprocity failure, and need for conversion filter. Particularly convenient are the self-contained, inexpensive, AC-operated flash units (*right in photo*) that fit standard screw-base bulb sockets (including sockets of Polaroid MP-4 system). Typical Polachrome exposure is f/11. Unit shown is from Spiratone; similar equipment is distributed by Morris Photo.

Copystand photography is not limited to opaque originals lit from above. The copystand and camera also can be used for translucent and transparent subjects lit from below.

A fluorescent light box provided sub-illumination for these fall leaves; no top lighting was used. When using a fluorescent light box with Polachrome film, filtration is usually required (see pages 30-31).

Use a sheet of plate glass to flatten book pages and other curved surfaces. Spines of books and magazines force page surfaces to tilt at an angle (*right*), which can cause distortion at sides of image (*far right*). Use cardboard or magazines as shims under bound publications so that pages to be photocopied are reasonably parallel to baseboard.

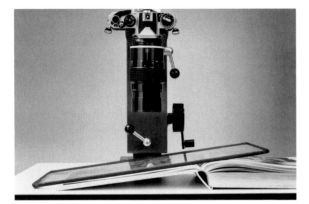

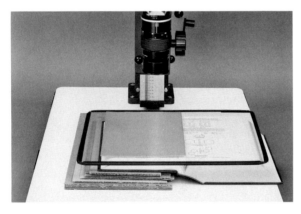

Determine exposure by placing 18% gray card over original, after composing and focusing and after attaching any appropriate filters (*top*). Set camera on "Manual," not "Automatic"; use gray card reading to take actual photo. Apertures of f/8 to f/16 are generally recommended. If corresponding exposure time is longer than ⅛ second, increase exposure to correct for reciprocity failure (pages 66-69). Note that with tungsten illumination, ISO speed of Polapan is 80/20°, Polagraph 320/26°.

If exposure reading is taken directly off subject with white background (*bottom far right*) without using gray card, severe underexposure will result (*bottom right*). Even when using gray card, exposures should be bracketed to compensate for variations in reflectivity of original and calibration errors in metering systems.

Reflections of camera, copystand, and ceiling may appear in the glass used to flatten books and artwork (*right*), particularly if original has broad, dark areas. Eliminate reflections (*far right*) by suspending black cardboard between camera and subject; attach cardboard to lens rim with step-up adapter ring. Use largest possible piece of cardboard that will not block light.

Photographing video images

Polaroid 35mm instant films are ideal for recording color or monochrome images of video display screens, including computer terminals, medical imaging devices, personal computers, TV monitors, and high resolution CRTs.

Best results are obtained when Polaroid 35mm films are used in the special 35mm camera systems that are provided as accessories by the manufacturers of video imaging equipment, such as the Polaroid VideoPrinter Instant Color Film Recorder (contact Polaroid Technical Assistance for information). When imaging from a personal computer, best results are obtained with a Polaroid Palette computer image recorder or a similar unit.

Alternatively, the screen can be photographed directly with a tripod-mounted 35mm single-lens-reflex camera that is fitted with a macro lens or close-up attachment. The immediate results from Polaroid 35mm films allow you to check exposure, alignment, and color quality, and to ensure, particularly with a scanning system, that the image is complete and correct before altering the display or moving ahead to another image.

The finished slide can be projected, used to make various size prints, and even converted to overhead transparencies using a desk-top, instant slide printer (see pages 84-89). The quality of instant prints from slides of video images is very good since video images tend to be graphic and of moderate brightness range.

Direct photography of the monitor

To directly photograph an image on a monitor, use a tripod-mounted single-lens-reflex camera with manual exposure control. A 50mm-55mm lens can be used, but a 100mm-135mm lens is preferred since it decreases the distortion caused by the slightly curved face of the screen. Macro lenses are ideal, macro-zooms usually satisfactory, and supplementary close-up lenses, which are attached to the lens like a filter, will give many nonmacro lenses quite adequate close-up capability.

For best contrast and to eliminate reflections, the room should be completely dark. Adjust the screen for maximum brightness consistent with optimum contrast. Set the lens to f/11 and determine the shutter speed by a bracketed series of test exposures: with Polachrome start at about 3 seconds; Polapan, 1 second; and Polagraph, ¼ second. Use a cable release.

▷ Accurately align the lens axis perpendicular to and centered on the screen. Ensure the alignment by carefully observing the monitor and camera from the side (*right*) and then from the top.

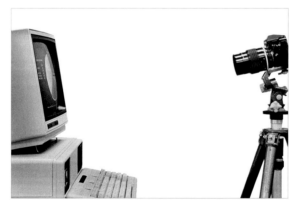

Courtesy Radio Shack

▷ This Polachrome slide was made using the handheld Screenshooter shown above right; exposure was 2 seconds at f/9. The image is from a personal computer with a high resolution screen. To eliminate moiré pattern that occurs when high resolution screens are photographed with Polachrome film, the defocusing technique discussed on the next page was used.

▲ More convenient for direct screen photography than a tripod-mounted camera is the Screenshooter Kit, manufactured by NPC Photo Division. The kit includes a lightweight CRT hood that places the camera at the correct distance from the screen and eliminates the need to darken the room. Also included are a modified Polaroid OneStep 600 camera for instant prints, and a hood mount and supplementary close-up lens for that camera. An additional bracket and extension tube enable you to use a 35mm single-lens-reflex camera with the hood. The exposure for Polaroid 35mm instant films will be the same as those listed above.

Moiré stripes may be visible when Polachrome film is used to directly photograph full screen images from high resolution color video monitors (*right*). This pattern will not occur with conventional color TV monitors or with monochrome screens. Moiré stripes and other optical patterns caused by curved screens and lens aberrations are easily eliminated without affecting sharpness (*far right*) by *slightly* defocusing lens. Focus accurately first, then turn lens toward closer focus. Test series of very small focusing changes will establish a setting for taking photographs for that camera-to-screen distance.

Courtesy Brilliant Image, Inc.

Polaroid Palette computer image recorder

While direct photography of the monitor produces satisfactory slides in many cases, far greater convenience, quality, and choice of image colors are obtained with specially designed computer image recorders. These peripherals plug into the host computer and contain their own optically flat, high-resolution CRT which reduces moiré patterns, ensures uniform focus, and minimizes geometric distortion. They are driven by special software, and offer camera backs for various formats from slides to large prints.

Of the systems available, the Polaroid Palette computer image recorder is extremely versatile. It operates with the most popular personal business computers, such as the IBM, IBM-compatibles, the DEC Rainbow, and the Apple IIe.

Polaroid Palette photographs can have higher resolution and offer a greater variety of colors than the images displayed on the monitor. The colors are chosen from 72 hues in the Polaroid Palette ColorKey. The ColorKey may be modified by the user or software vendor, effectively making the color choice virtually unlimited.

With the Polaroid Palette recorder, the color fidelity and saturation of the photographs are consistently excellent with *any* of the seven Polaroid instant films *or* conventional films used. This is because the software incorporates automatic compensation for the spectral characteristics of each particular film. (Compensation for additional films may be added by the user.) Therefore, image colors are comparable and equivalent—from film type to film type.

Polaroid Palette computer image recording system comes complete with automatic 35mm motor-driven camera (shown), pack film back for Polaroid instant color prints, a full Polaroid 35mm instant slide system, and all necessary cables, software, and instructions.

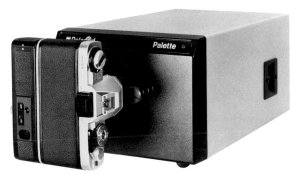

Very high resolution video image recorders

Numerous companies offer sophisticated video image recorders that are used when the highest quality slides and prints are required. There are two kinds. Like the Polaroid Palette recorder, some are driven by a separate computer, contain their own CRTs, and accept 35mm and other format camera backs. Others (display-driven), such as the Polaroid VideoPrinter Instant Color Film Recorder, have their own microprocessors to control the exposure process.

Resolution is as high as 4000 x 4000 pixels, and special software incorporates very flexible color selection, excellent quality type fonts, and provisions for anti-aliasing (elimination of "stair-step" edges in lines and curves).

Since high resolution systems often take many minutes, sometimes over an hour, to expose one image, and because most computer monitors do not display precisely the same range of colors actually generated on the film by the image-recording camera system, Polaroid 35mm instant films are often very useful. Many video image recorders have included exposure values for Polachrome film. Some systems, however, are factory-set for only one conventional slide film, typically of ISO 64/19° or 100/21°. When using Polachrome film (ISO 40/17°) additional exposure can usually be obtained by simply opening the lens: ⅔ stop from 64/19° to 40/17° and 1⅓ stops from 100/21° to 40/17°. *Check with the equipment manufacturer before attempting any adjustments.*

Comparison of computer imaging systems

This Polachrome slide was made by directly photographing a high resolution personal computer monitor, 640 x 200 pixels, using a tripod-mounted camera. With careful camera alignment, proper aperture, and elimination of screen glare, the results are limited only by the resolution and color range of the monitor. Filters are generally not required when directly photographing a properly adjusted monitor.

The same computer image as above was transmitted from a personal computer into a Polaroid Palette recorder. Note the improved definition and color of this slide, which contains 640 x 400 pixels.

The best quality slides come from very high resolution, sophisticated computer image recorders. In this case, the resolution was 4000 x 4000 pixels.

Printing press reproduction and color separations

To reproduce a photograph or transparency on a printing press, the image must be converted to a form that is compatible with the printing process selected, such as offset lithography or letterpress. To print a high-contrast image, such as one produced on Polagraph film, the printer makes a line shot. To reproduce a continuous tone, black-and-white image, such as one from Polapan film, the printer makes a halftone or duotone. A color image, such as a Polachrome slide, requires color separations.

Line shots, halftones, duotones, and color separations can be successfully made from Polaroid 35mm films with the same techniques used when printing conventional materials. However, there are several important handling differences that must be observed to avoid damaging the original slide and to ensure optimum reproduction of the image.

Some printers may not have experience working with these materials. The information below should be brought to their attention, as well as to that of your art department, advertising agency, designer, or publisher.

Emulsion side

The metallic, silvery surface is the emulsion side of Polaroid 35mm films. The image is right-reading when looking at the *emulsion* side; conventional films are right-reading when looking at the *base*.

When film is electronically scanned, Polaroid 35mm film should be mounted with its emulsion side facing the drum. This produces better sharpness on most scanners and also protects the emulsion. With the emulsion down, the image will be wrong-reading; the scanner controls should be set to produce a "flopped" or mirror image.

Handling Polaroid 35mm slides

Polaroid 35mm films are significantly more susceptible to softening by chemicals, and to scratching and abrasion, than are conventional films. They should be handled as little as possible and cleaned *only* if necessary, and then, very gently, with a minimum of solvent (use Kodak film cleaner); cleaning the emulsion side may slightly affect the color balance. Do not soak a Polaroid slide in cleaning solvent. (For additional handling information, see pages 60–61.)

The film can be mounted on the drum with tape, but apply the tape *only* over the sprocket holes. Tape must be kept off the image area on the emulsion side as the image may lift off when the tape is removed.

The slide can be mounted with oil, but be careful not to scratch the surface when removing the oil. (This procedure is usually unnecessary at low magnifications.) For dry mounting, anti-Newton-ring powder can be used.

Color separations of Polachrome slides

Polagraph and Polapan films can be converted to line shots or halftones without any special considerations other than the handling suggestions noted above. However, Polachrome film requires further attention for two reasons.

First, Polachrome film has a higher base density than conventional films. This higher base density, coupled with its silvery surface, requires that the slide be evaluated on a light box using a loupe with an *opaque* base.

You should not evaluate a Polachrome slide by casually holding it up to a light or by using a transparent base loupe.

Second, there is a screen of red, green, and blue filter stripes in its base, 1,000 color triplets per inch (394 per centimeter). These stripes will become just visible on the printed page when the image is enlarged 400% to 500%. Visibility increases with higher magnification, finer screen rulings, and greater amounts of unsharp masking.

At specific combinations of screen ruling and image magnification, the filter stripes interact with the screen dots and produce moiré patterns which vary from subtle to severe. Moiré, if present, will be most visible in large areas of light tonality; "busy" scenes will hide the stripes. Moiré patterns can be eliminated in scanning systems by following the procedures explained below.

Scanning Polachrome slides

The following steps for electronically scanning Polachrome slides may require modification to suit individual needs and specific images. Additionally, conditions, procedures, and equipment vary considerably from shop to shop. If Polachrome film has not been separated previously, we strongly suggest performing tests on sample, noncritical slides.

1
Align the film sprocket holes parallel to the long dimension of the drum. Place the emulsion side down, facing the drum.

2
White balance must be calibrated on the Polachrome film itself, *not* on a separate gray scale. To calibrate the white balance, find a white (clear) area of the image. Defocus so the filter stripes in the film base are totally invisible. Set the white balance control.

If there is no white image area, press a piece of tape very carefully over the sprocket holes *only*. The tape will remove the black coating and leave an area of clear film base.

3
When checking other color values in the image, continue to keep the filter stripes totally out of focus.

4
Turn off unsharp masking or set the controls to the minimum levels. If more than one scanning aperture is available, choose the largest aperture.

5
Refocus the filter stripes before beginning the scan.

6
Scan as you would conventional film. If the Polachrome slide was exposed under proper lighting conditions, color balance should be similar to that used for conventional film, but tests will be required.

7
If moiré patterns appear on the separations, realign the slide on the drum at a moderate angle, about 30° to 40°, so that the sprocket holes are no longer parallel to the drum axis. If the moiré pattern persists, realign the slide again and try a larger scanning aperture.

An alternative method for eliminating moiré has been suggested by some separators. Follow steps 1–3 above. Refocus the filter stripes in the film base, then *slightly* defocus–the stripes should be visible, but blurry. Then *increase* unsharp masking to prevent the image from looking too soft. Tests will be necessary to establish satisfactory levels of defocus and unsharp masking.

Appendix:
Troubleshooting guide

Incomplete frame at end of film roll

A fogged, incomplete image indicates this is frame 37 or 38 on a 36-exposure roll (or frame 13 or 14 on a 12-exposure roll). Polaroid 35mm film cartridges contain slightly more film than conventional cartridges; the additional length is required for proper processing. However, take no pictures after frame 36 (or 12) even though the film can still be advanced.

No image on processed film

Shown here is the beginning of a developed roll of Polaroid 35mm film. The black area is the film leader, and the silver area indicates that the film *has been processed.* If either the entire roll or individual frames are blank, the film received no or insufficient exposure. This could be caused by a mechanical defect in the camera or, if flash pictures were taken, an improperly set flash synchronization.

If the entire roll is blank, more likely the film did not go through the camera. When loading film, make sure that the film leader is securely attached to the take-up spool. For safety, wrap two full turns of film around the take-up spool before closing the camera. Also, after removing any slack in the film cartridge by turning the camera's rewind knob, check that the rewind knob is moving when the film advance lever is operated.

Totally black processed film

If the entire length of film is totally black (not silver) when removed from the AutoProcessor, no development has taken place. This is caused by failure to attach either the film or the processing pack strip sheet securely to the appropriate pins on the Auto-Processor's take-up spool. If this happens, unused processing reagent may collect on critical parts of the AutoProcessor (see page 61 for processor maintenance directions).

Black film edges

Ragged, black material along one or both edges of the long side of the film results from incomplete stripping of the negative layer during processing. This is usually caused by turning the Auto-Processor crank too slowly, and occurs more often when the film is processed below 70°F (21°C). The black material can be easily removed by peeling it off with a piece of tape (see page 60 for details).

Unless the black edges are obviously severe when examining the processed, but unmounted film, you can postpone the tape procedure until the *mounted* slides are examined, because the slide mount often covers the ragged edges. If necessary, the slide can be easily removed from its mount and the negative layer peeled off later.

Underexposed Polagraph slides

Polagraph film is frequently used to make slides of line art on predominantly white backgrounds. Since exposure meters are calibrated for medium-tone subjects, severe underexposure will result (as shown here) if readings are taken directly from the artwork. Set the camera on "Manual" (not "Automatic"), and take the exposure reading from an 18% gray card placed over the artwork (see pages 49 and 103). Compensate

for reciprocity failure when exposure times are longer than ⅛ second (see pages 66-69). In addition, under tungsten illumination, remember that the ISO speed of Polograph film is 320/26°.

Correctly exposed Polagraph slides may appear too light if the film is not allowed to develop for the correct time. The processing time for Polagraph film is always 2 minutes (not 60 seconds.)

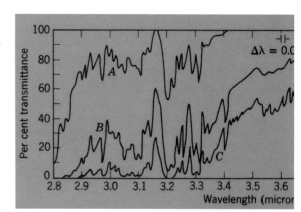

Underexposed bounce flash slides

A flash unit's distance scale, which indicates the maximum range at a particular lens aperture, is calibrated for direct not bounce flash.

Most camera-mounted electronic flash units have insufficient power to take bounce-flash pictures in a medium-to-large room with an ISO 40/17° rated film such as Polachrome. This is particularly true when using lenses

that have a maximum aperture smaller than f/2. The example shown here is a product of these circumstances.

Bounce flash may be possible with small flash units at short distances in rooms with low ceilings. However, in most cases, direct flash is required to obtain properly exposed Polachrome slides.

Overexposed flash slides

Overexposed images (right) result when Polaroid 35mm films are used at normal ISO settings with off the film flash metering systems. Correct off the film flash exposures are possible with most cameras if a compensated ISO is used.

To avoid the need for special ISO settings and potential difficulties with some cameras, use

the automatic sensor found on most flash units instead of the off the film sensor. (See pages 74-79 for a full discussion of flash photography.)

Overexposure also results when the subject is too close to an automatic flash. Consult the flash instruction manual for the distance range with each lens aperture.

Skive marks

The serrated streaks on the right side of this photo are caused by improper use of the cutting knife on the Polaroid slide mounter. To prevent skiving, apply light pressure toward the left when pushing the cutting knife down (see page 12).

If the cutting knife eventually becomes dull after mounting many thousands of slides, replace the slide mounter.

Acknowledgments

The author wishes to thank the following individuals and organizations for their generous support in the preparation of this book:

HCM Graphic Systems, Inc. for tests related to color separations;

Nikon, Olympus, Minolta, and Pentax corporations for advice and assistance with equipment;

Three Village Camera, Inc. for logistical support;

and the following people for assistance with individual photographs: Patt Blue, Kathy Bonai, Bobbi Brown, Susan Contento, Michael and Andrea Edelson, Bernard Furnival,

Marjorie and Natanya Groten, Anne and Robert Hoefler, Benjamin Lefkowitz, Bernd Minderjahn, Lawrence Shaper, Fred Spira, Patricia Tuccio, and John Wessels.

Suppliers of materials

Polaroid films and equipment are readily available from your photographic dealer, or contact Polaroid Technical Assistance (see page 5). Other equipment and materials mentioned in this book are also available from your local dealer, or write to the manufacturers:

Artronics, Inc.
300 Corporate Court
P.O. Box 408
South Plainfield, NJ 07080

Brilliant Image, Inc.
141 West 28 Street
New York, NY 10001

Carolina Biological
Supply Co., Inc.
Burlington, NC 27215

NPC Photo Division
1238 Chestnut Street
Newton Upper Falls, MA 02164

Optical and Electronic
Research, Inc.
11501 Sunset Hills Road
Reston, VA 22090

Spiratone, Inc.
135-06 Northern Blvd.
Flushing, NY 11354

Visual Horizons, Inc.
180 Metro Park
Rochester, NY 14623

P2302A 2/86 MT/AC
Printed in U.S.A.